THE BETTER DIGITAL PHOTOGRAPHY GUIDE TO

Special Effects and Photo-Art

Argentum

First published in Great Britain 2006 by Argentum, an imprint of
Aurum Press Ltd, 25 Bedford Avenue, London WC1B 3AT
www.aurumpress.co.uk

A catalogue record for this book is available from the British Library.

ISBN 1 902538 40 4

1 2 3 4 5 6 7 8 9 10
2006 2007 2008 2009 2010 2011

Designed by Toby Matthews, toby.matthews@ntlworld.com
Packaged & Concept by Angie Patchell
at emergingartbook producers, www.emergingart.co.uk

Printed in Singapore

THE BETTER DIGITAL PHOTOGRAPHY GUIDE TO

Special Effects and Photo-Art

Michael Busselle

THE BETTER DIGITAL PHOTOGRAPHY GUIDE TO

Special Effects and Photo-Art

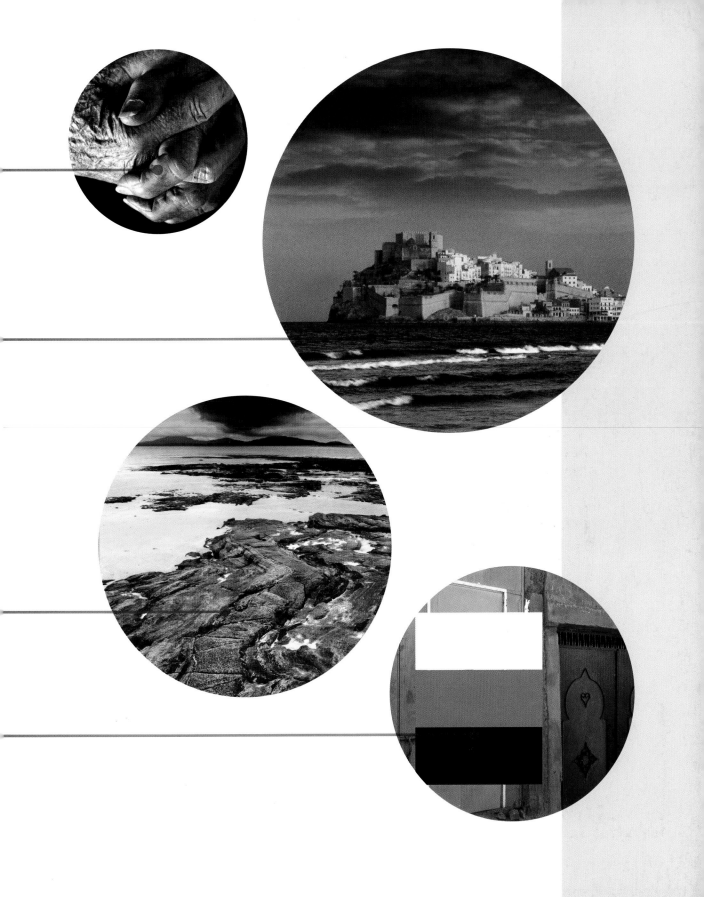

Introduction

The photographic process has reached a very exciting stage in its development and now offers more possibilities than ever before to those who choose to use the medium as a means of personal expression.

I've been a professional photographer for more than four decades and the changes that I have seen take place in the last few years are the most sweeping advances of all. I believe these changes have made working as a professional photographer much easier in a purely practical way. These new innovations have liberated photographers from many of the more mechanical and tedious aspects of image making and encouraged a more experimental and adventurous approach to photography.

"Special Effects and Photo-Art is intended to both instruct and inspire the reader to see creatively without restrictions and preconceptions"

I consider myself to be as much a keen amateur photographer as I am a professional, and making images is one of my greatest pleasures. As a professional photographer you tend to be readily categorised as, for example, a still life, landscape or fashion photographer. But as an amateur, when you shoot pictures purely for personal satisfaction, it's much more rewarding to be able to seek inspiration in a variety of subjects and situations.

This is the basis of Special Effects and Photo-Art which is intended to both instruct and inspire the reader, not only to see creatively without restrictions and preconceptions, but also to harness all the advantages of the modern photographic process in order to realise the full potential of their images.

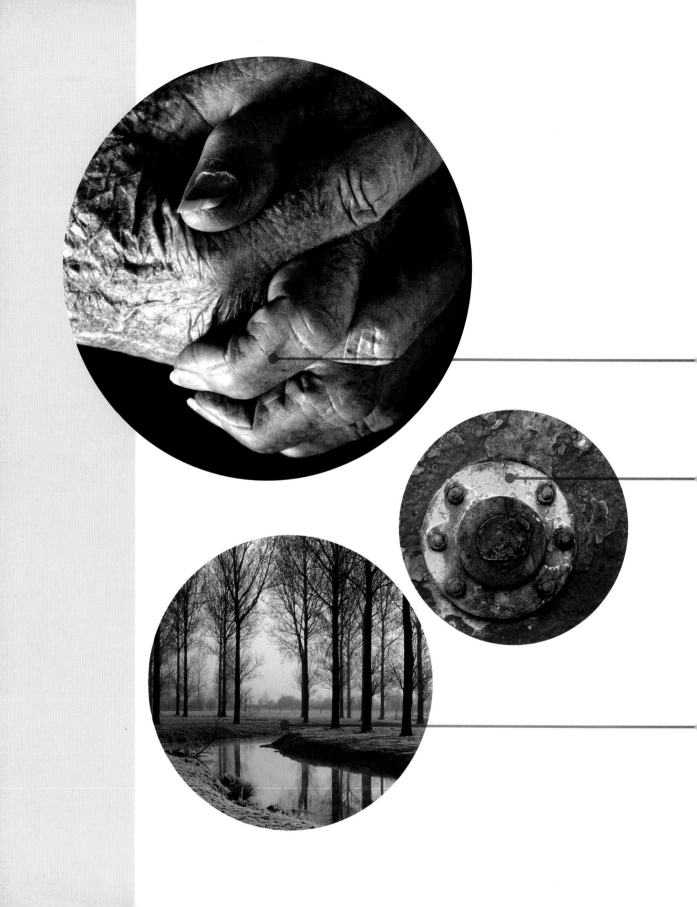

9 steps to capturing images

choosing the subject

It's not unreasonable to believe that the subject of a photograph should be something which is visually attractive in its own right. After all, the term photogenic is frequently used as a simile for pretty or beautiful. But this isn't always the case and, very often, a conventionally beautiful object can produce a far less interesting and striking photograph than something which is distinctly unattractive. The series of still life photographs which Irving Penn made of discarded cigarette butts is a good example of this.

● ● ● The Key To

The key to what makes a good subject for a photograph is whether it has one or more of the essential visual attributes, such as shape or pattern, which convert so well into a 2D image. If none of these qualities exists then even the most beautiful object is unlikely to produce a satisfying image.

Colorado Car Wreck

Driving along a country road in Colorado, I was astonished to suddenly come across a field littered with the remains of vintage cars and trucks in various stages of decay. The owner readily gave me permission to wander around and take photographs. Apparently restoring these vehicles was his hobby and he simply could not understand why I was much more interested in the rusting wrecks than the three or four gleaming, as-new examples he showed

me in the barn. I tried to explain how photogenic the texture and colour was of those outside but I'm sure he thought I was mad.

I used a wide-angle lens in order to shoot from a close viewpoint and exaggerate the perspective. I shot from an angle which made the most of the vehicle's shape and gave me a sympathetic background. I used a small aperture to ensure the image was as sharp as it could be from front to back.

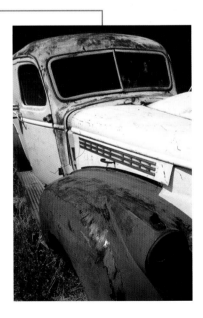

Branch Reflections

This shot was taken on an overcast day while travelling along the edge of a small artificial lake in the Andalucian mountains. Some small trees and bushes had been partially submerged by the rising water level and, because there was little wind and disturbance to the water's surface, they had created some interesting reflections. The trees were some distance from the edge of the lake and I needed to use a long-focus lens in order to fill the frame with the reflections.

I thought the image worked well as pure black and white but also wondered if just a hint of colour might add a little more atmosphere. I had in mind the bluish tint obtained when making cyanotypes. I opened a new layer above the image—the background layer—and filled it with a light blue. I then set the Blend mode to Multiply and made a final adjustment to the effect by using the sliders in Layer Options.

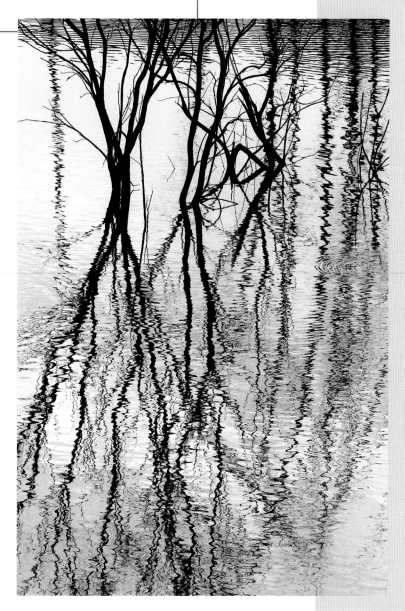

There is an understandable desire for photographers to go to places which are inherently beautiful in order to seek their images, and this is especially so in the case of landscape photography. It may well have been Ansel Adams who was responsible for the almost cult-like obsession with spectacular views among landscape photographers and it's not hard to understand why when you look at his stunning images of places like Snake River and Yosemite. But, as many who have made pilgrimages like these will know, success is by no means guaranteed. Unless the lighting and viewpoint create the essential visual triggers which make for an eye-catching image the outcome is almost certain to be disappointing.

> **"Unless the lighting and viewpoint create the essential visual triggers which make for an eye-catching image"**

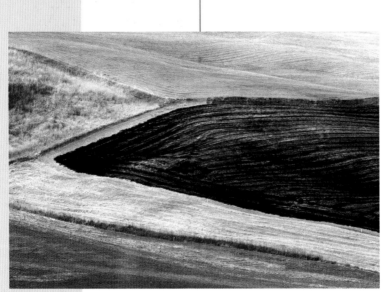

Burnt Field

I was driving through the Sierra de Tejeda in Andalucia in the autumn when I spotted this scene. It's the time of year in this region when the landscape is burnt by the sun to a pale sepia and can often lack the qualities which translates into an interesting image, especially on a day when the sky was hazy and the light diffused with barely defined shadows as this one was. But the stubble had been burnt in some of the fields creating some boldly defined shapes and a contrast of textures. I used a long-focus lens to frame a small area of the scene quite tightly and in a way which produced an almost abstract arrangement of the shapes and colours.

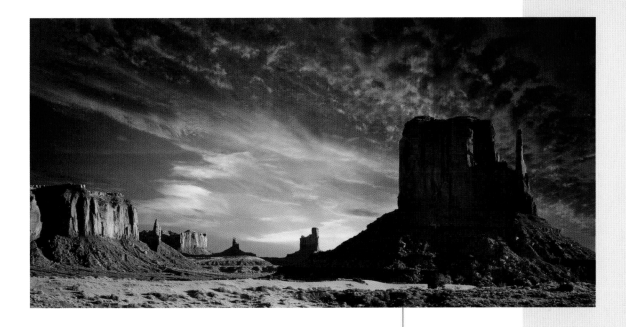

Monument Valley

I'd timed my arrival in Arizona's Monument Valley so that I would be able to photograph it in the evening light. I anticipated this time of day would best reveal the colour, texture and shapes of the rocks. I'd also had the benefit of seeing many other impressive images shot at this time of day. You can imagine my frustration on discovering that the national park had closed for the day a short time before I arrived—a distinct lack of adequate research.

I had to settle for the early morning light, making sure that I entered the park the minute it reopened. The effect of the low-angled light was striking and it took only a short while to find this classic viewpoint. I used a wide-angle lens to show the broad extent of the scene and to include the most striking of the rock formations.

I was quite pleased with the captured image as the shapes, texture and colour of the landscape had been thrown into quite bold relief by the warm, acutely-angled lighting. But I was only too aware that my picture fell far short of many others I'd seen in terms of impact. I felt this was partly due to the bland blue sky which was unbroken by cloud and the use of the wide-angle lens meant that I'd had to include a large area of it. Drawing on my collection of sky images, I selected one which I thought would marry well with the landscape. Then using the method described on pages 68–69 I superimposed the landscape onto the new sky.

seeing colour

Most photographers respond readily to a colourful subject, like a garden in bloom for instance. But a colourful subject, no matter how stunning it is to look at, is not necessarily going to translate into a good colour photograph.

Boatyard

I seem drawn to anything to do with boats and a fishing harbour is a favourite place for me to look for pictures. This shot was taken in a boat yard where there was a rich variety of rusting hulks and peeling paint. This particular boat was, I imagine, in the process of being repainted and I loved the rich colours and element of pattern which it possessed. Although it was a strikingly multicoloured subject there was still a single very dominant colour which extended over the image area. This dominant colour, combined with the impression of a pattern, has helped the other colours to blend together and create a harmonious whole, with the wooden trestle creating an essential focus of interest.

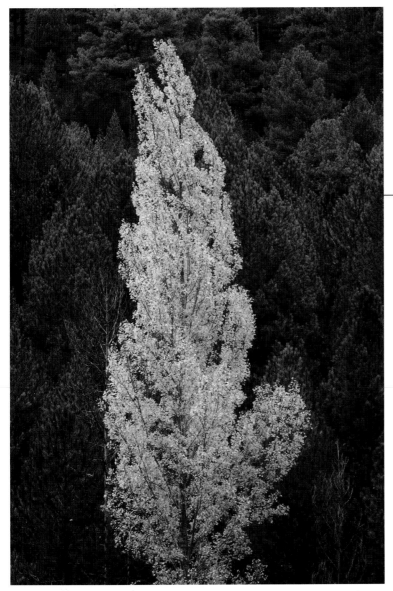

Golden Tree

I drove along the upper valley of the river Ebro in Spain last autumn and it was lined with trees which had turned to this glorious golden hue. The difficulty was in finding a situation where I could isolate one or more trees in a way which emphasised the colour and provided a contrasting background. This single tree was ideal as it was set against a backdrop of evergreens and, although the sky was overcast and the light very soft, the colour contrast was great enough to create a bold effect. I used a long focus lens to frame the tree tightly and to exclude some distracting colours and details each side.

The only adjustment needed was to increase the contrast a little using Curves and to slightly exaggerate the colour of the tree using hue and saturation. I also used the burn tool to tone down a few lighter areas in the background.

It's necessary to be very observant and discerning when choosing subjects and composing your pictures if you are to produce striking images which stand out from the crowd. You need to notice exactly what and where the colours are, and bear in mind that a splash of colour in the wrong place can be just as distracting and unattractive as an ugly pylon in the midst of a serene landscape.

seeing monochrome

Just as a subject needs to be seen in a particular way for colour photography to be really effective, so shooting in monochrome needs another very different visual approach.

Many photographers, myself included, dislike having to shoot both colour and black and white on the same assignment because the two disciplines are so different. It's essential to ignore the colour content of a subject when shooting in monochrome and learn to look only at the tonal graduations it possesses.

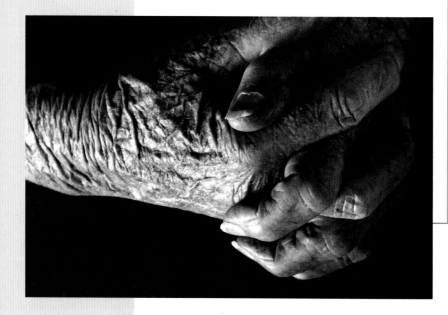

Old Hands

This picture was spontaneous as they are the hands of my very elderly mother-in-law clasped quite naturally as she sat at her kitchen table. Using the light from a window I took the shot without any alteration to her pose or the lighting and framed her hands tightly using a long focus lens. The light level was quite low so I used a sensor setting of ISO 400, which created only a small amount of noise. With the camera mounted on a tripod I was able to use a small aperture and slow shutter speed to ensure there was enough depth of field to create sharp focus over the most important area of the subject.

I used the Channel Mixer to reduce the red sensitivity of the image which has enhanced the skin texture and produced a richer range of tones. I also used the burn tool to darken the table surface which was pine and had a rather distracting grain.

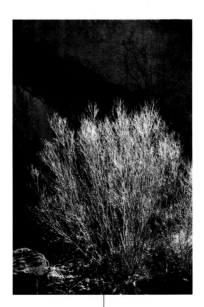

Colour can be a real red herring because it can mask the tones of a scene. For instance, a still life of a single red apple in a basket of green ones is visually striking, but in black and white the red apple would be a very similar tone to the green ones and the result would be a flat and uninteresting image without the technique described on pages 60–61. Good monochrome images depend on more than just contrast and elements such as shape, form, texture and pattern are vital for the production of strong, eye-catching photographs.

"This subject appealed to me because of the backlighting which has lit the bare branches of this small bush in quite a dramatic way"

Burning Bush

This subject appealed to me because of the backlighting which has lit the bare branches of this small bush in quite a dramatic way. The contrast of the shaded and slightly textured rock face behind it has created a strong contrast which has emphasised the shape of the bush and thrown the individual branches into bold relief. I used a long focus lens to frame the subject tightly and to exclude unwanted and distracting details.

I thought that the image would lend itself well to a toned effect and decided to apply the lith type effect, which is described on pages 62, with the shadow tones having a slightly bluish tint and the lighter tones a sepia hue.

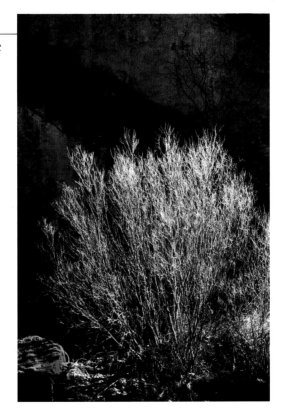

being selective

Choosing a suitable subject is only the first of a series of decisions which needs to be made when in pursuit of a successful photograph. The next is to become aware of exactly what it is you want to shoot. A dozen photographers confronted with the same subject will almost certainly finish up taking a dozen different photographs.

The Key To

The key to producing striking images is in understanding that the subject itself is not the most important factor. It can help to view potential subjects through half-closed eyes as this will subdue the subjects identity and allow elements like shape, colour and texture to be more clearly seen.

"It's necessary to learn to see a subject in terms of it's visual characteristics, you do need to see the trees and not just the wood"

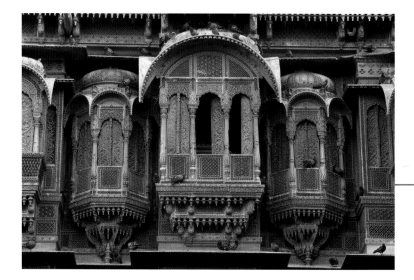

How you make your selection is initially based on what you consider to be the most important features of a scene or subject. Inexperienced photographers will usually simply see something they think will make a good photograph and shoot it without further thought. However, this will invariably lead to an indifferent picture.

Jaiselmer

These two photographs were taken in the Indian city of Jaiselmer which is celebrated for its wealth of ancient houses with ornately carved balconies. This particular street is a glorious sight and I was keen to capture some of its unique architecture. I made a number of shots looking down the street showing as wide a view as my wide-angle lens would allow, but was conscious that what these images gained in atmosphere and a sense of place they lacked in architectural detail. For this reason I decided to take some shots using a more frontal, square on viewpoint. The street was quite narrow but using my **24mm wide-angle shift lens** I was able to shoot one of the most striking houses from ground to roof and was quite pleased with the effect which was rich in texture and the pattern effect created a pleasingly ordered image. But I was also aware that the photograph lacked impact, there was simply too much going on in the image and no positive focus of interest. I decided to be much more selective and concentrate on much smaller details of the building's facade. From a very similar viewpoint to the first picture I switched to my **70-200mm zoom lens** and explored the effect of framing some of the individual balconies. Several of them worked well but this was the shot I liked best.

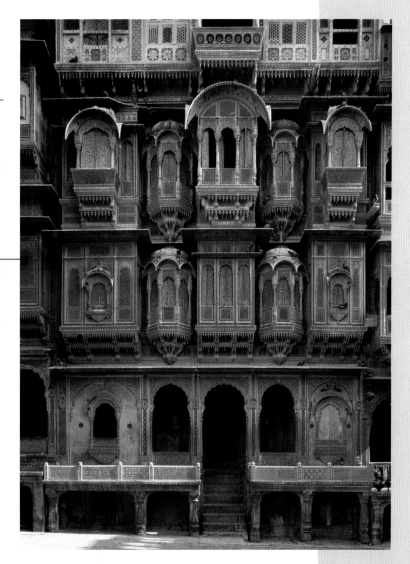

Quite often you will discover the subject you are considering may well produce two or more telling photographs than one single all encompassing image. It may also be the case that the setting or background of a subject could be an important element of the image and to include a wider area of a scene is a better option. One big advantage of digital capture over film is that the cost of making exposures is negligible and, on top of this, it's possible to see the result almost immediately. In many ways a digital camera is a perfect learning aid since it can be used to make instant comparisons between different ways of shooting a subject.

Rusty Winch

One of my favourite haunts is Dungeness on the Kent coast. In truth it's a rather bleak and scruffy place but I invariably find something interesting to photograph there. There's a wealth of semi-derelict machinery dotted along the beach mostly used by the fishermen who haul their boats up onto the shore. Some of it is in a gloriously rusty state and I've always had a fondness for rust and decay. This shot is of a winch, My first approach was to include all of it in the frame because it had an interesting shape but I found it impossible to find a viewpoint where I could isolate it from the untidy and distracting background. A more careful look at the object made me realise that the most striking element of the subject was a blue axle set into a rusty red panel and, on framing this small area quite tightly, the image took on a much more graphic and abstract quality with a bold colour contrast.

Westward Ho

A late winter's afternoon produced these lighting conditions on the beach at Westward Ho in North Devon. The sun was still very bright and the scene almost too contrasty so I waited a while until some cloud veiled the sun a little more. I chose this viewpoint in order to include the foreground of wet sand and the distant headland and waited before making my exposure until the lone walker moved into the right position. I contemplated selecting just the beach as far as the distant horizon and making perhaps a separate shot of the cloud and the area below the walker. This would have had the advantage of reducing the contrast problem as the difference in brightness range between the sky and the dark sand in the foreground was considerable. But I didn't have much time to decide as the lone figure was moving out of place and I liked the idea of combining the two elements and capturing the sense of space which the beach evoked.

"I chose this viewpoint in order to include the foreground of wet sand and the distant headland and waited before making my exposure until the lone walker moved into the right position"

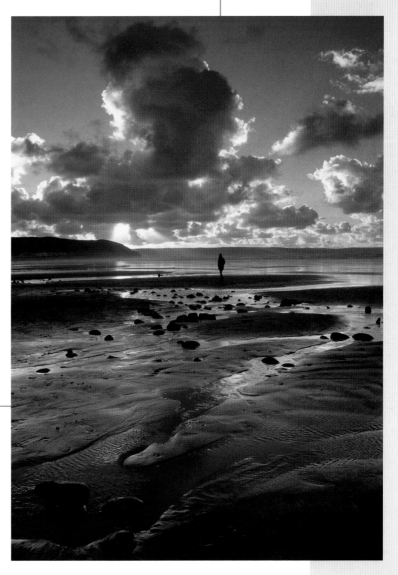

choosing a viewpoint

I think that one of the most enjoyable aspects of photography, and certainly one of the most important, is finding the best viewpoint for a shot. The choice of viewpoint is often the one decision which determines the basic character of an image and yet it is the one thing which inexperienced photographers often give little thought to.

The choice of viewpoint can influence many aspects of the image, such as the effect of perspective, the way a subject is lit and the ultimate composition of the image. Even a change in camera position of just a metre or so can make a significant difference, especially when a wide-angle lens is being used. As there is often more than one option, I will frequently take shots from several different viewpoints and the process of exploring them will often reveal possibilities which I was unaware of when I first saw the subject.

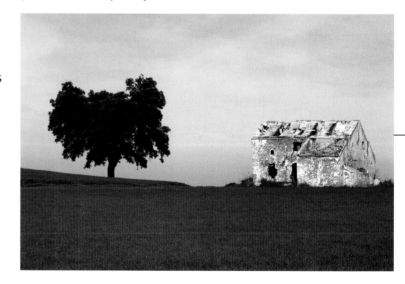

Ruined House

I spotted this derelict house while driving through the Sierra de Morena to the north of Seville and was attracted by the almost pastel quality of the flaking plaster and crumbling roof. I felt that this was enhanced by the weak, rather bleached quality of the sky and I don't think it would have appealed to me so much had the sky been the usual deep blue you expect in Spain.

My first view of the house as I came round a corner was the image on the previous page and it was the combination of house and tree which first struck me. As I walked back after parking my car I watched how the relative positions of the two main elements had changed. My first thought was to go as far to the right as possible in order to show them closer together. But I found that if I went too far the

perspective of the house became much less attractive as it showed too much of the end wall and not enough of the front elevation. I took a number of shots varying the viewpoint a little from left to right and using my zoom and camera tilt to vary the amount of foreground and sky. After downloading the images I decided to settle for the viewpoint shown here.

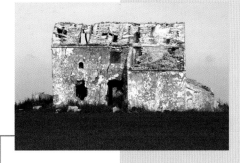

After taking this shot I thought that the house was interesting enough to shoot on its own and chose a viewpoint which showed a full frontal view of the ruin using a longer focus lens to frame it quite tightly.

I'd parked my car at the entrance to a track which led to the ruin and I walked along it to see if I could use it as a lead in to the picture, a

device which often helps to create a strong eye-catching quality. After exploring a few different options I decided on this view which, with the use of a wide-angle lens enabled me to have the track leading directly from the camera to the house and also showed a little of its continuation beyond it. A fringe benefit of using a wider angle was that it showed an area of darker sky at the top of the frame which I thought gave the sky a bit more definition.

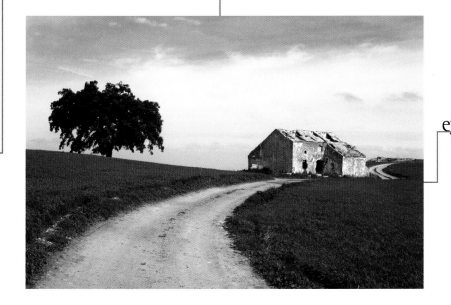

> **"A winding track is a device that often helps to create an eye-catching quality"**

> **"Shooting from a lower or higher camera position can often have a very striking effect on the composition of an image"**

One reason why I find looking for viewpoints such a fascinating process is the way the spatial relationship between fixed objects can be so readily altered. By moving to the left objects close to the camera will move to the right of more distant details and vice versa. Moving closer to an object will make it seem larger in relation to more distant things while moving further away will make it appear smaller. It is this that makes it possible to control the content of an image to a considerable extent and the reason why a group of photographers shooting essentially the same subject can come up with quite different images. It's worth noting that the majority of photographs are taken from about eye level but that shooting from a lower or higher camera position can often have a very striking effect on the composition of an image.

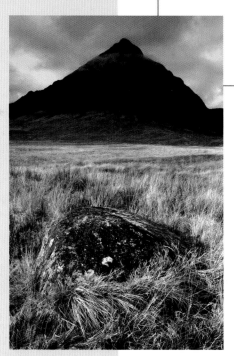

Buacaille Etive Mor

At the entrance to Glencoe the distinctively shaped peak of Buachaille Etive Mor must be one of the most photographed features of the Scottish landscape. Unfortunately, on the late autumn day of my visit the sky was overcast and the light very diffused creating only faint shadows. On top of this the landscape lacked colour as it had already taken on that rather dead appearance of winter. I'd almost decided to move on pictureless when I spotted this boulder which had a striking texture, it was not very large so I used a very wide-angle lens and a close viewpoint in order to make it appear about the same size as the distant peak and create an even balance between them.

I used the channel mixer to convert the image to monochrome adjusting the sliders to extend the tonal range to the maximum. I then used the dodging and shading tools to make the mountain and sky darker and to maximise the texture and contrast of the rock.

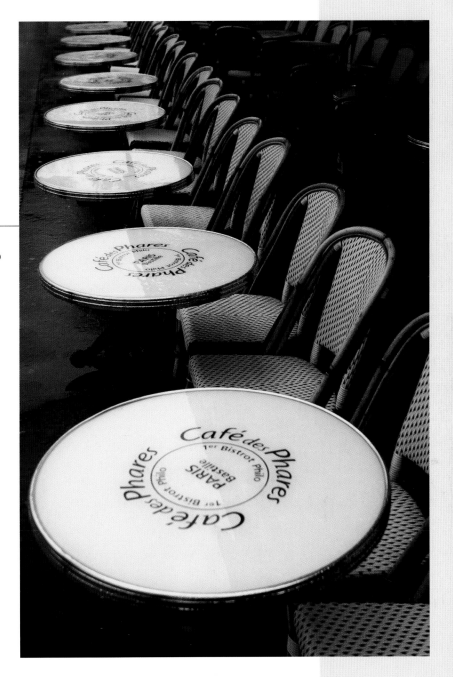

Cafe Tables

I find Paris is always an inspiring place for photography, there are so many small details which appeal to me as well as the more obvious sites. This shot was taken during a trip in late November and the weather was pretty bad with dark cloudy skies for most of the time. The soft light which this creates is often ideal for urban photography, especially when photographing details in black and white. These cafe tables caught my eye partly because they were unoccupied but also because the light from the sky was illuminating the shiny white table tops in a way which made them seem to glow. I used a wide angle lens from a close viewpoint in order to exaggerate the perspective and sense of depth. I framed the shot tightly so that all the emphasis was on the shapes of the tables and chairs.

I converted the image to black and white using the Channel Mixer and colourised it by applying the Gradient Map in the way described on pages 62–63, and made a final adjustment to the density and contrast using Curves.

placing the frame

It might seem a bit fanciful to compare the camera's viewfinder to a painter's canvas but it has much the same significance because what goes into it is ultimately up to you. The way you place the frame is part of the process of composition along with selecting the subject, choosing a viewpoint and using the light and it is rare that any of these decisions can be made in isolation.

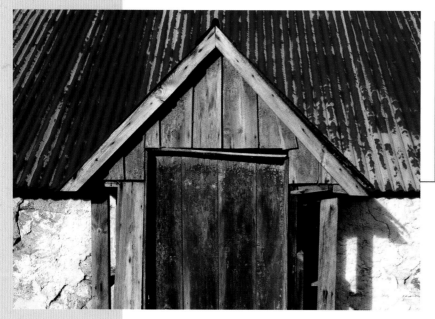

Derelict Cottage

I came across this neglected old building while driving along a country lane in a remote part of Scotland. My interest was triggered by the variety of textures and colours in the wooden door and corrugated iron roof. There were several opportunities for pictures here and I spent some time sizing up a number of possible shots. I decided in the end that the most interesting features were contained in the area immediately around the door and I chose a viewpoint which was square on to it. As a general rule it's good advice to avoid a completely symmetrical image or to place the focus of interest in the centre of the frame. But in this case I felt it created the most striking effect as well as making the most of the strong geometrical shapes.

Being constantly aware of all the possibilities and how making a change to one factor can affect the others is essential for good composition. It is possible to create a pleasing image which does not have a readily identifiable focus of interest but pictures that do have one tend to be more satisfying to look at and have greater impact.

> **❝The key to good composition is to be constantly aware of all the possibilities and how making a change to one factor can affect the others❞**

Winchelsea Beach

It was a hazy late summer evening when I arrived at the beach with the tide far out. There were still a few holiday makers on the beach who I wanted to avoid as my intention was to shoot some moody seascapes making use of the weathered wooden breakwaters and the wet rippled sand. I had begun to set up a shot of this area framing it initially as an upright with the highlighted sand in the foreground. But when I saw these two children heading my way I thought they would provide an effective focus of interest. Anticipating where they would cross my field of view, I framed the scene as a landscape shape in a way which would place the children towards the right corner of the frame as I felt this would create a better balance than it would with them placed at the intersection of thirds.

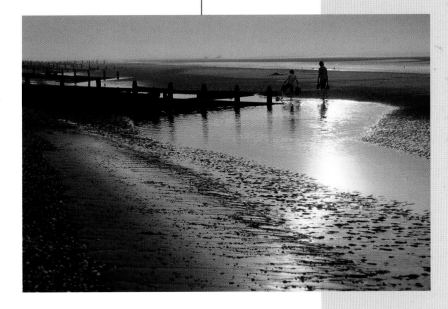

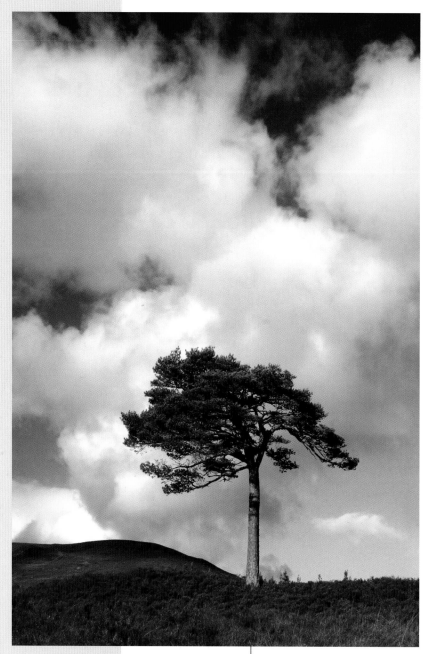

Scots Pine

I have a particular liking for trees, especially single isolated trees and this one caught my eye as I drove along the shores of Loch Awe in Scotland. It was set on a steep bank bordering the road which enabled me to take a low viewpoint and set the tree against the sky. I thought it was a very nice shape and I set up with a view to framing the tree quite tightly against the deep blue sky. But as I did so I saw some clouds approaching and they too formed a very nice shape as they came into view above the tree. I quickly changed to a wider setting on my zoom lens and tilted the camera up to include the full extent of the cloud. This placed the tree close to the bottom of the frame which I thought created a comfortable balance.

Like most things in life, there are rules governing composition but they should not be adhered to slavishly. The 'golden rule' states that the focus of interest should be placed within the frame at a point where lines dividing the space into thirds horizontally and vertically intersect. It's a good rule of thumb since following it will usually produce an image which looks pleasingly balanced. But there are very many situations where a much stronger and more interesting image can be created by considering the alternatives. Ultimately it is a question of balance; if you can achieve a more balanced composition by placing the focus of interest in the centre of the frame or close to one corner then you should do so.

> **"The 'golden rule' states that the focus of interest should be placed within the frame at a point where lines dividing the space into thirds horizontally and vertically intersect"**

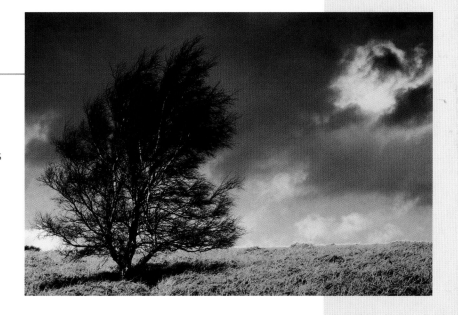

York Tree

The North York moors in winter can be a cold and windy place and many of the trees here have this windswept look. I particularly liked the shape of this one and the cloudy sky behind it had some good rich tones. I was setting up to shoot a more conventionally composed image with the tree placed nearer the centre of the image when this bright patch suddenly appeared in the sky. I quickly altered the way I'd framed the image so that the tree and the highlight were in opposing corners. I felt this was the most effective way of combining the two elements and liked the sense of tension and movement that it created.

I used the Channel Mixer to render the image as black and white and then used the Gradient Map to add the colour in the way described on page 63. I made a final adjustment to the contrast and density of the images using Curves.

using light

If one aspect of photography could be singled out as the most important, it is the interaction of light and subject. The quality and direction of light is crucial to the creation of a quality image and an essentially uninteresting subject can often be transformed into a powerful and evocative image simply by the way it is lit.

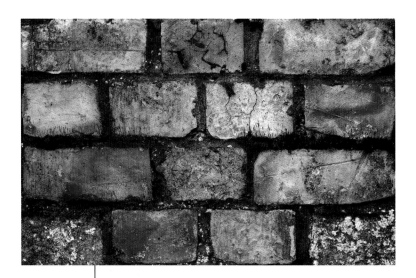

Old Bricks

I spotted this subject as I was taking a walk near my home on a very dull, cloudy day. I was drawn to it because of the striking pattern together with the bold texture and colours of the stone. The light was so diffused that there were virtually no shadows and more distant scenes appeared flat and lifeless. These conditions, however, were ideal for this subject, photographed from just a few feet away. Had there been strong, dominant shadows, the subtle texture and colours of the weather-worn bricks would have been largely lost.

The key to becoming fully aware of the way light affects a subject is to study the shadows. Ask yourself, how dark are they, how big are they, what direction do they take and how soft or hard are their edges?

> **❝I liked the soft, luminous quality of the first hint of sunlight from the eastern sky❞**

The Créquoise Valley

This shot was taken early on a midwinter's morning in northern France when a heavy hoar frost had covered the landscape. It appealed to me on several levels. I liked the almost monochromatic quality which the frost had created and I also liked the orderly arrangement of the trees and the texture of the grass. But above all, I liked the soft, luminous quality of the first hint of sunlight from the eastern sky. I framed the image so that the base of the trees bisected the frame as I felt this created the best balance.

I chose a viewpoint which placed a triangle of river bank in the foreground and created a nicely balanced arrangement of trees with the river entering from the edge of the frame to create a diagonal.

I imagine many people regard a bright sunny day as the best time to take photographs and there's no doubt that sunlight does give images a certain sparkle and clarity. But if the sky is cloudless the lighting quality can be quite uninteresting and uninspiring. The presence of clouds means that sunlight is being both diffused and reflected and this can create a much wider range of effects. Even a completely overcast day when the sun creates no shadows can be a much more suitable light for many subjects and those days when large cumulus clouds are scudding across the sky can make photography very exciting indeed with the way it affects a subject often changing by the minute.

Beach Stones

I found these large boulder-like pebbles on a remote beach on the Isle of Barra in the Outer Hebrides and was attracted by their round smoothness and the extraordinary range of colours and textures. I found a viewpoint which enabled me to frame a group of the most interesting stones but the unobscured sunlight was creating very dense and hard-edged shadows which partially obscured the subtle shapes and tones of the stones as well as creating a harsh and unappealing quality. There were some isolated clouds in the otherwise clear blue sky and I estimated that there was a good chance that the sun would be obscured for a while if I waited. As soon as this happened the scene was transformed as the much softer diffused light enabled the beautiful shapes and colours of the stones to be revealed.

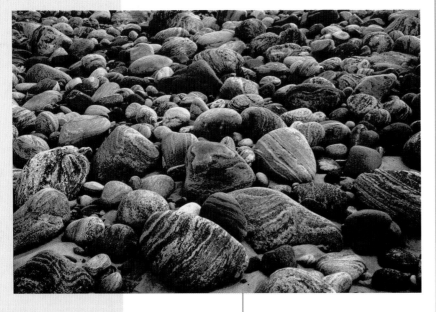

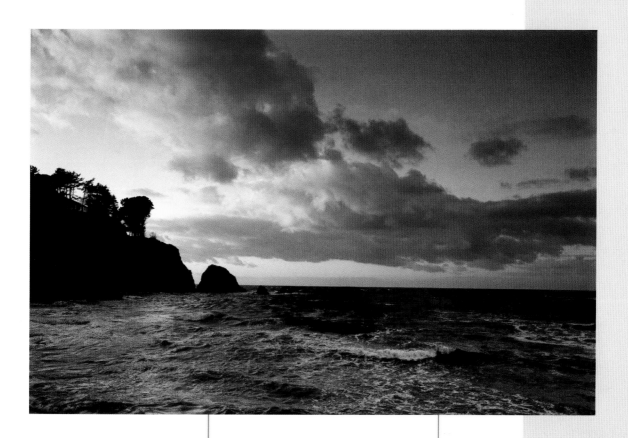

Lee Bay

This is a place I visit often as my son lives there on the north coast of Devon. Although I have taken many pictures of this small rocky bay over the years I'm always fascinated by how the most familiar location can take on a completely different look according to the lighting conditions. The setting sun is not visible from the bay but I've shot pictures using it's effect many times. The light at this time of day, and first thing in the morning, is highly valued by landscape photographers for its warm mellow quality and the rich textures the acutely angled light creates. On this occasion my viewpoint allowed me to obtain the effect of the setting sun as it illuminated the cloud over the bay and its reflection in the sea added to the richness of colour in the image. I used a wide angle lens to include as much of the cloud as possible and framed the image so that the brightest part of the cloud was balanced by the darker area of sea and sky on the right.

> **"My viewpoint allowed me to obtain the effect of the setting sun as it illuminated the cloud over the bay"**

selecting the exposure

Getting the exposure right is not the issue it once was. Even modestly priced cameras have metering systems which will produce a well-exposed image in most situations. The occasions when relying upon auto-metering is likely to record a poor quality image are not that numerous and are fairly predictable.

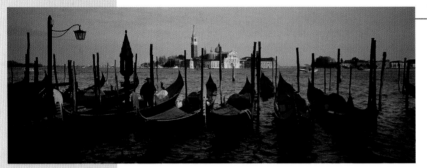

It's necessary to understand that an exposure meter works on the principle that what it is being aimed at will record as a mid tone. On the occasions when this produces an incorrect exposure it is invariably because the subject contains a disproportionately large area of either very light tones—creating underexposure, or very dark tones—creating overexposure. Overexposure will result in detail being lost in the lighter tones of the image and underexposure will produce an image with little or no detail in the darkest tones.

Venice

The quality of sunlight near the end or the beginning of the day is something I always try to make use of and this scene in Venice was so much more atmospheric at dusk than during the day. The foreground of gondolas was very much darker than the distant building, still lit by bright sunlight. But I thought it made a pleasing composition and I shot it giving one stop less exposure than the camera's meter suggested to make sure that the building was not overexposed.

The resulting image was very dark in the foreground area so I used the Dodging tool with a large brush set to Midtones and an exposure of 15% to make it lighter. I followed this by using the same tool set to highlights in order to lift some of the brighter tones on the tops of the gondolas.

Underexposure is the most commonly encountered problem and the most frequent causes are when the subject contains bright light sources, such as a street scene at night, when there is a large area of bright sky in the viewfinder and when shooting into the sun. It also occurs when the subject itself is very light in tone, such as a bride wearing a white dress or a white-washed cottage.

Overexposure is likely to occur when the subject is inherently dark in tone, such as a close-up of a black cat or a person with a very dark skin. Excessively large areas of shadow in an image will also cause overexposure, such as the common situation of shooting a brightly lit scene from a dark interior, perhaps through a window or doorway.

When you are aware of a circumstance which could cause a wrong exposure you can use the exposure compensation setting to increase or decrease the reading accordingly. Alternatively, you can take a close up, or spot reading, from a detail within the subject which represents a mid tone.

> **"Excessively large areas of shadow in an image will cause overexposure"**

Troutbeck

Snow can create a few problems for photographers as well as motorists, not least the need to capture it while it is freshly fallen as even a short time after it can begin to look rather drab and pitted. I was lucky enough to experience a snowfall while on a visit to Cumbria and was able to shoot some pictures while it was still falling. This photograph of Troutbeck was taken soon after it began and elements of the landscape are still visible beneath the snow. I find this can add some interest and texture to the image especially, as in this case, when the sky is overcast and the light so diffused that it creates virtually no shadows. I chose a viewpoint which placed the lightly covered field with its hint of colour in the foreground and framed the image to include the distant hilltop. I gave one stop more exposure than the camera's meter suggested to avoid the snow being recorded as grey.

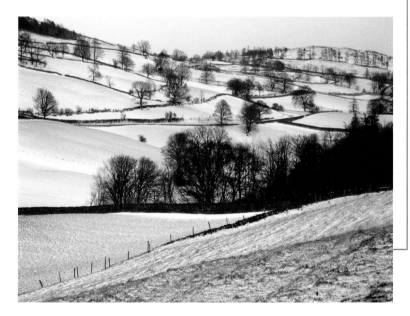

controlling sharpness

In my experience there are few things more
frustrating and disappointing in photography than
downloading an image which appears, at first glance,
to be a winning picture only to discover, on closer
examination, that it is not sharp.

Chestnut

In the autumn I like to go and
collect a few chestnuts from some
fine old trees in a park near my
home. This one fell at my feet and
looked so pristine and shiny that I
almost felt obliged to photograph
it. I used daylight from a window
as the illumination with a piece
of white card propped close to
the chestnut on its shaded side to
keep the contrast at a manageable
level. I used a macro lens in order
to fill the frame and set it to the
minimum aperture of f32 to obtain
as much depth of field as possible.

I used the Channel Mixer to convert
it to a black and white image
adjusting the sliders to create the
widest range of tones. The colour
was added by using Gradient Map
in the way described on page 63.

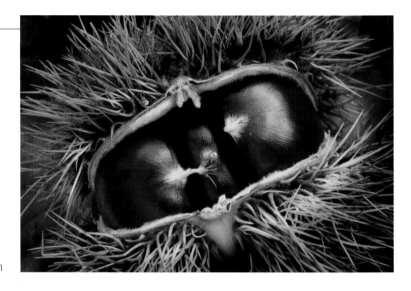

When you are photographing a static subject such as a
landscape or a building there is no reason why the image should
not be sharp, providing you use a tripod. It's worth bearing in
mind that it's impossible to eliminate camera shake completely
even using the very fastest shutter speeds. Even a very slight,
barely noticeable degree of camera shake can lose that crucial
crisp edge to image sharpness.

It's a different matter though when photographing a moving
subject and to prevent blur it's necessary to depend upon using

a fast shutter speed. It's difficult to estimate what speed is necessary to freeze a moving subject as it depends upon the speed of movement, its direction in relation to the film plane and its distance from the camera.

Another consideration concerning image sharpness is that of depth of field. This is the area which acceptably sharp in front of and beyond the point at which the lens is focused. It is dependent upon the distance at which the lens is focused and the aperture which has been set. The depth of field will increase when the lens is focused on more distant objects and when a small aperture is used, and will decrease when a wide aperture is set and the lens is focused on an object close to the camera. At normal focusing distances the depth of field extends about twice the distance behind the subject to that in front of it.

While a sharp image is essential to the quality of most pictures, blur has numerous creative possibilities when it is planned and not simply an accident. Blur which results from shallow depth of field, for example, can make subjects stand out more boldly from the background and blur caused by movement can produce some very exciting effects.

Tree Blur

I stopped to shoot some pictures of the autumn colours as I drove through a forest in Scotland. While using my tripod and the lens stopped down to get maximum sharpness it occurred to me that this might make a good subject for a more abstract approach using camera movement to create blur. Having selected this area of the scene as the most promising I began to make a series of exposures varying both the speed and direction of the camera, now hand held, as well as the shutter speed. I checked each image as I shot it to see the effect and used this as a guide to making changes. In all I probably made about 20 or more exposures, most of which were binned on the spot, but three or four I felt worked well and this was one I liked best.

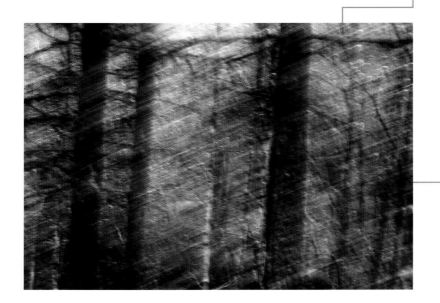

"Blur caused by movement can produce some very exciting effects"

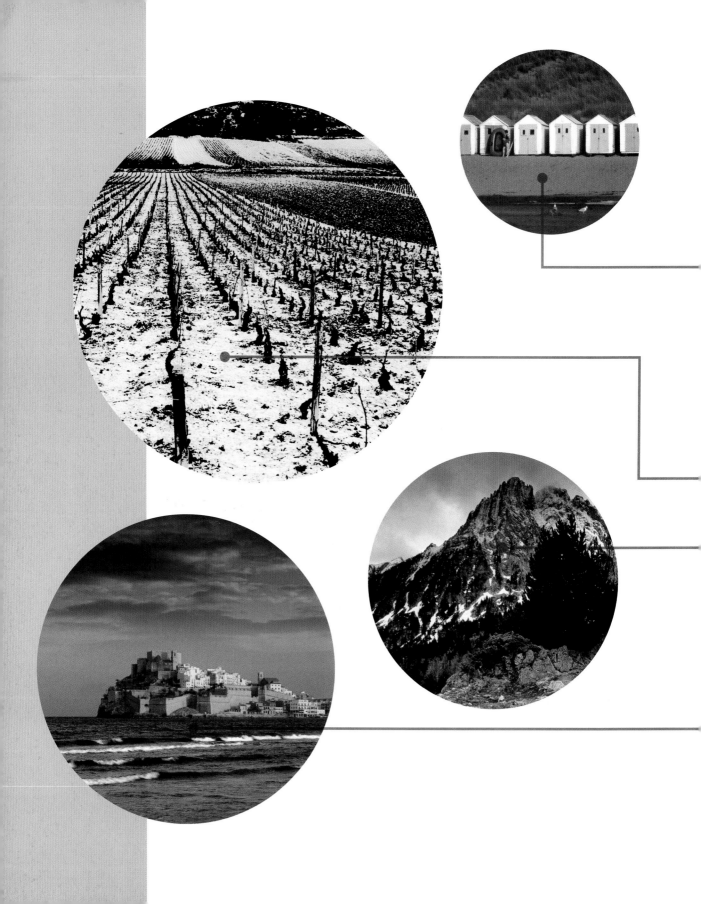

8 steps to enhancing images

cropping and tidying

I'm sure those of you who have been accustomed to working with film will agree with me that one of the most annoying and time-consuming aspects of film is dealing with dust and scratches. A digital image has the big advantage that any marks can be easily and invisibly removed.

It is also a simple matter to ensure that the image area is exactly right. This has the advantage of not only making sure that the image has maximum impact but also, when saved, the image file is no bigger than it need be. Many cameras have a substantial safety margin built into the viewfinder which can result in unwanted details being included in the captured image. If these are cropped out before you begin editing it will save both time and disk space.

"Shooting digital often makes it possible to produce a winning picture when film would have deterred you from taking it in the first place"

In addition to removing blemishes using the cloning tool it is also relatively simple to remove many other intrusive details which would otherwise detract from the picture. When working with film there have been numerous occasions when I've decided not to shoot a potentially good picture simply because there has been something like a vapour trail in the sky or a pylon in a landscape. Shooting digital often makes it possible to produce a winning picture when film would have deterred you from taking it in the first place.

Beach Huts

I used a wide-angle lens to shoot this picture of beach huts on Woolacombe beach because I wanted to show as much of the long row of huts as I was able. But this has also meant that a large area of rather unattractive, grass-covered sand dunes behind them was unavoidably included. Cropping the image to a panoramic shape was an obvious first step but the image was also a little messy. I used the cloning tool to remove some of the litter and to eliminate the waste bin I used the Marquee tool to draw a rectangle slighter larger than the bin on the sand beside it and feathered the selection a little. I then copied this and pasted it over the bin doing any necessary tidying up using the cloning tool.

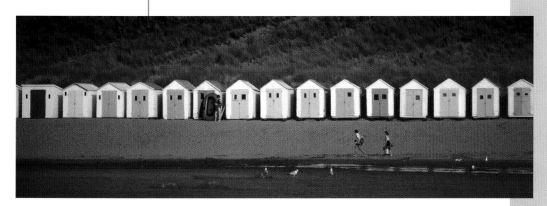

density and contrast

It's not always appreciated just how much difference the density and contrast can make to the quality and atmosphere of an image, and creative adjustment of both can produce dramatic effects.

original shot

In purely technical terms these values should be such that there is a pure black in the image with detail in the shadow areas as well as in all but the brightest highlights. But in creative terms it is necessary to adjust the image levels to produce the effect you have visualised.

The simplest way to adjust the contrast of an image is to use Auto Contrast or Auto Levels. The former sets the darkest tone in the image as black and the lightest as white while the latter does much the same but with each colour individually. This can produce some striking effects on occasions especially when the image has a pronounced colour bias and it's always worth trying this option first. If the result is very extreme, for instance, it can make a blue sky an unnaturally vivid hue it's possible to use the Fade facility in Edit to modify the effect. But for the greatest control over both contrast and density the Curves tool in Image>Adjustments is by far the most flexible and useful.

White Trees

I saw these trees while driving in the mountains near Malaga and was attracted by their slender silvery trunks. It was a dull, overcast day and actually raining when I took the photograph. This meant the light was very diffused and soft which suited the subject very well except for a lack of contrast. I used a long focus lens to frame the tidiest area of the plantation where the trunks formed a pleasing arrangement.

The captured image was predictably very soft and I used Auto Levels initially to set the 'correct' contrast level. But this did not produce the effect I wanted as I'd visualised the tree trunks as almost glowing. Using the Curves control I made the shadows considerably darker and also brightened the highlights to the point where they were almost pure white. This gave me the effect I'd hoped for.

❝I saw these trees while driving in the mountains near Malaga and was attracted by their slender silvery trunks❞

Darkroom workers depend a great deal on their ability to control the density and contrast of their images not just overall but in specific areas. The key to producing high quality silver gelatin prints is often in the use of shading and dodging techniques but they are quite limited in what they can achieve. But the digital worker has an enormous degree of control and very specific areas of an image can be selected so that not only can the density be adjusted but also the contrast and the colour quality if needed.

original shot

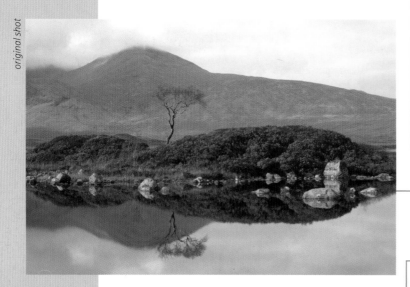

> **"Specific** areas of an image can be selected so that not only can the density be adjusted but also the contrast and the colour quality**"**

Rannoch Moor

It was an overcast day as I drove through Rannoch Moor in Scotland and the light was very soft casting only weak shadows. But the presence of water in this scene had the potential to produce a pleasing image. I chose a viewpoint which allowed me to use the water as a foreground and placed the tree close to the distant peak framing the image so that they were more or less at the intersection of thirds.

The photograph as captured was predictably lacking in contrast and the first image shows the effect of adjusting the levels. I wanted the image to be much richer than this though and image two is the result of increasing the contrast and making it darker. I also wanted to make the sky darker so I selected this area using the magic wand tool and used Curves to achieve this.

It was still not quite there so I used Curves to make the image darker still overall, and also the sky after reselecting it, producing the result in image three.

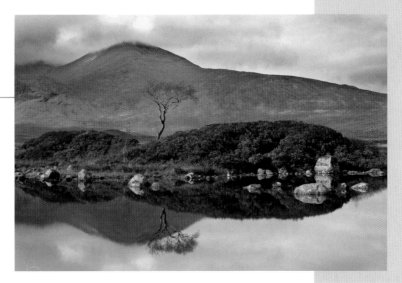

The final image was the result of using both the burning and dodging tools to make the shadows a little stronger in the sky, also on their reflection in the water and on the mountainside. I also lifted the highlights on the heather-covered bank.

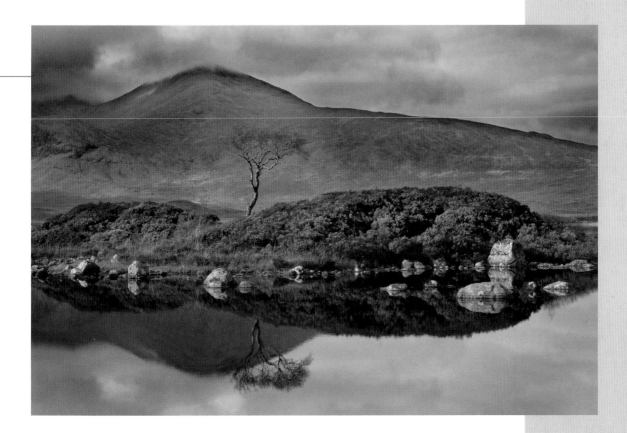

controlling colour

Light varies in colour enormously from the orange
hue of a setting sun to the strong blue bias of open
shade under a blue sky. Add to this the range of
colours which artificial lighting can create and the
possibility of a subject being captured with its true
colour is seemingly slight.

> **"I used Curves to make the magenta bias more neutral by adding some green to the mid-tones."**

White light balance is a major consideration with film but
digital cameras have an automatic white light balance which
largely overcomes the problem. Most captured images will
display a fairly accurate rendition of the colours in a scene. But
if the colours in an image are inaccurate, or simply not to your
taste, there are a number of ways of changing them.

The Hue and Saturation sliders found in Image>Adjust are the
most basic way of varying the colour quality of an image. Hue
alters the colour bias of an image from blue through green
to red, while saturation changes the purity of a colour with a
minus value creating a weaker, more pastel hue while a positive
value makes the colour much richer and stronger. This can
be done overall or with each primary and secondary colour
individually. I find reducing the red saturation an effective
way of making the skin tones in a portrait more flattering, for
example.

A more flexible and subtle way of achieving a similar result is to
use Levels or Curves where it is possible to alter the colour of
individual tones, making the highlights more blue for example
and the shadows more red. The permutations with this method,
especially using Curves, are virtually endless.

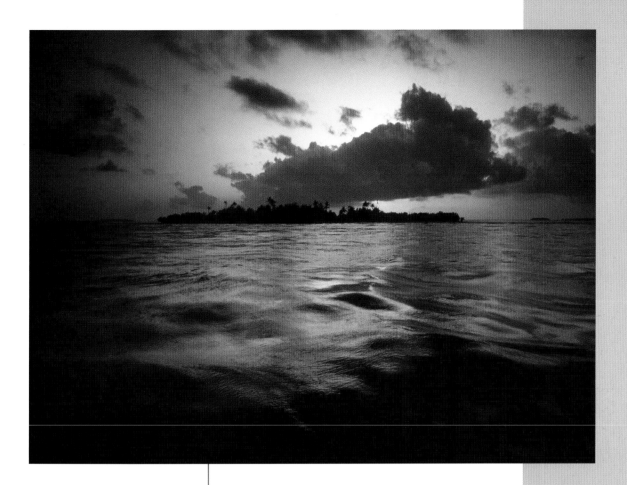

Maldive Sunset

I shot this picture while travelling in a fishing boat between several of the islands in the Maldives and, having stayed out longer than I intended, it was a wonderful situation to see the sun setting over the Indian Ocean. I used a wide angle lens in order to include as much of the sea and sky as possible and used the fastest feasible shutter speed to freeze the movement of the boat.

As I recall, the captured image is a pretty accurate rendering of the scene with a quite pronounced magenta bias. I used Curves to make this more neutral by adding some green to the mid-tones. Although less colourful I think I prefer this version but I also wanted to see how the image would look with a more golden tint which I added, using Curves, by reducing the magenta and adding red and yellow.

"If the red light is reduced in power there will be a cyan cast, less green will create a maganta bias and with less blue the result will have a yellow tint"

To have full control over the colour of your images you need to understand their make up. The primary colours are red, green and blue and if these three colours are projected individually with equal brightness onto the same area the result will be white light. If the red light is reduced in power there will be a cyan cast, less green will create a maganta bias and with less blue the result will have a yellow tint.

The secondary colours are cyan, magenta and yellow and when these three colours are printed onto a white surface with equal weight the result will be black. In practice, printing inks are not quite dense enough to create a true black so a black ink is also included in the printing processes, hence CMYK, K being the symbol for black. When the cyan ink is reduced the result will be a red bias and when less magenta is included in the mix there will be a green cast while less yellow will create a blue tint.

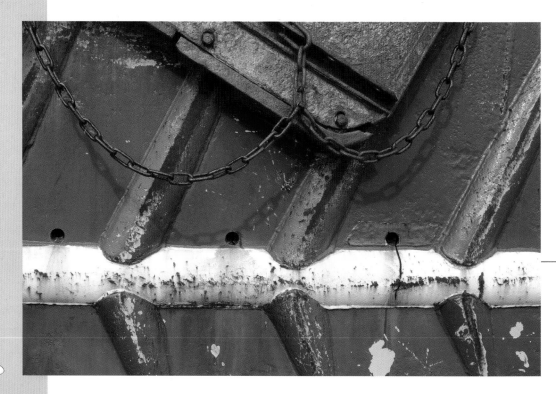

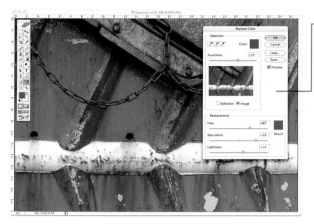

Image>Adjustments>Replace Color can be a very useful tool for altering a specific hue within an image. When the captured image has an acceptable colour overall, but one aspect of it is either inaccurate or not very pleasing to the eye, it's possible to select just this area of the image and change both its hue and saturation.

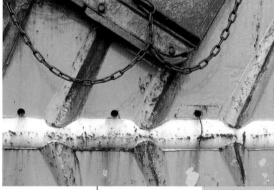

Boat and Chain

The original capture was the blue image but using replace colour has enabled me to create three very different versions of it.

creating special effects

The ability to create special effects using digital manipulation is almost awesome and there is a distinct temptation for those new to the process to use it to extremes. I know I did and still do sometimes.

Although some of the effects are very questionable from an aesthetic point of view it can be a great deal of fun and in experimenting with the various tools and filters you will almost certainly discover some interesting and useful techniques. It's important to appreciate that in spite of the apparent wealth of tools and filters many of them have very similar effects.

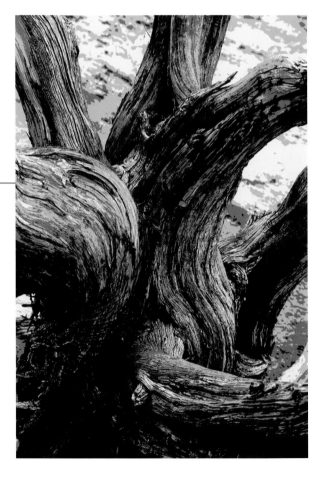

Posterised Tree Stump

My first step with this image was to convert it to black and white using the Channel Mixer to obtain the greatest possible range of tones and then I used the posterisation panel to select five steps. I next selected the darkest step using Select>Color Range. I chose a very dark brown from the colour picker to fill this selection and then deselected it in order to reselect the next lighter tone filling this with one shade lighter brown and so on with the remaining steps, making the white tone a very pale gold. I made final adjustments to the image using Replace Color and Curves.

Fishing Boat

This photograph was taken on an overcast winter's day on the Costa del Sol and the light was so diffused that only the bold colours have enabled the image to have any degree of impact. I chose a viewpoint which showed the pleasing lines of the hull to the best advantage with the sea and sky as a background and framed the shot to focus the attention on the most appealing section of it.

I thought that the image might gain more impact by using posterisation to simplify it and having tried various settings settled on six steps. It's important to appreciate that the effect will depend a great deal not only on the number of tonal steps you select but also the density and contrast of the image and the way the colour is distributed within it and it is worth

Posterisation

Posterisation, found in Image>Adjustments, is the name given to the process where a continuous toned image is rendered as a small series of tonal steps. With image editing software it is easy to do this and the number of tonal steps can be varied at will.

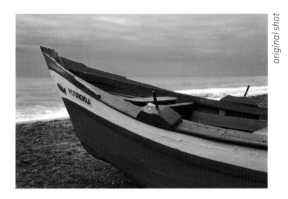

original shot

experimenting with all of these factors. In this case the colours are present in clearly defined blocks and the result is not too far from the original but in some cases the colours will be completely altered.

> **"With image editing software it is easy to create posterisation effects and the number of tonal steps can be varied at will"**

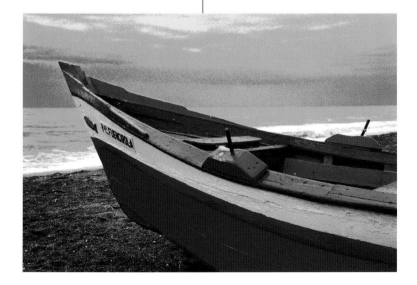

Temple Mosaic

This image was produced by a combination of three effects, Unsharp Masking, Poster Edges and Threshold. My first step was to apply unsharp masking to the colour image after I'd adjusted the density and contrast. I set the Amount to 500%, and adjusted the sliders for Radius and Threshold until I obtained the optimum effect. These settings will depend upon the file size and the nature of the image. In this case radius was set to 10 pixels and threshold to 5. It's important to judge these effects with the image displayed on the monitor at at either 25%, 50% or 100% because in between sizes will

not show the true image quality. I next applied **Filter>Artistic> Poster Edges** with the Edge Thickness set to zero, the Edge Intensity set to 10 and Posterisation set to zero. I then went to Image>Adustments> Threshold and adjusted the slider until I had the effect I wanted. I then selected the white tones using Select>Color

Range and filled it with a colour chosen from the colour picker.

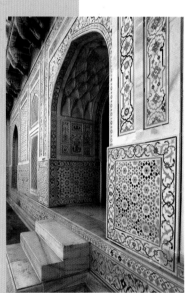

original shot

original shot

In my view the effects of most of the filters in programs such as Photoshop are a bit banal when used on their own and they only become interesting when their qualities are combined with other image manipulations. It's also important to appreciate that the ultimate effect of a filter will partly depend upon the nature of the image and an effect which works well with one subject will not necessarily do the same with another. In addition, the density, contrast and colour saturation will also have a big influence on the final effect of a filter.

> **"It's important to appreciate that the ultimate effect of a filter will partly depend upon the nature of the image and an effect which works well with one subject will not necessarily do the same with another"**

Spanish Door

The type of image which lends itself to this treatment is one which has lots of fine detail with some bold lines and shapes, is fairly low in contrast and lacks any large dark areas. For this image I reduced the contrast considerably and, having selected the wooden door, made this much lighter and brighter. Although any subject has the potential to be rendered in this way it does lend itself particularly well to architectural images.

The Threshold facility in Image>
Adjustments renders the image as just
solid black and pure white. With the right
image it can look quite interesting used on
its own in a poster-like sort of way. The
only control you have is using the slider
to determine at which point on the tonal
scale the image divides into black or white.
For this effect to work it needs an image
which contains lots of detail and does not
have large areas of dark or light tones. But
its effect can be more interesting when it is
combined with other image manipulations.

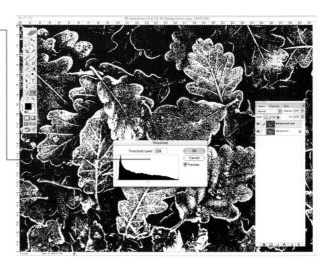

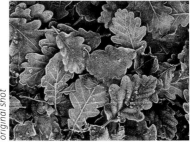

Leaves

The effect of this image of
frosted leaves was produced by
combining two layers of the same
image. I made a duplicate layer
of the captured image and went
to threshold using the slider so
that only the very darkest tones
were rendered as black while the
majority of the image was white.
I set the blend mode to Multiply
and then made a final adjustment
to the image by going to the
background layer, the original
capture, and altering the saturation
until I obtained the effect I wanted.

original shot

Winter Vineyard

I photographed this scene on a wickedly cold January day in Burgundy after a light snow fall. I find wine country a very satisfying landscape to photograph because the vine planting imparts a strong sense of order and pattern and, with some exceptions, the countryside is usually beautifully contoured. I chose a viewpoint which enabled me to place one of the wooden stakes in the close foreground and showed the vine rows in strong perspective and framed the image to include just a little of the hillside beyond the vineyard.

The method I used was very much the same as the previous image but I made the threshold image very light indeed and used Darken as the blend mode. I also increased the colour saturation of the background layer, the original capture, considerably and, after flattening the image, I used Curves to make the combined image very much lighter.

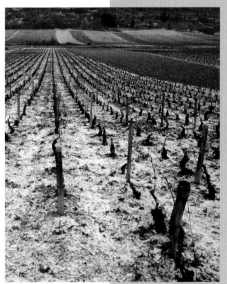

original shot

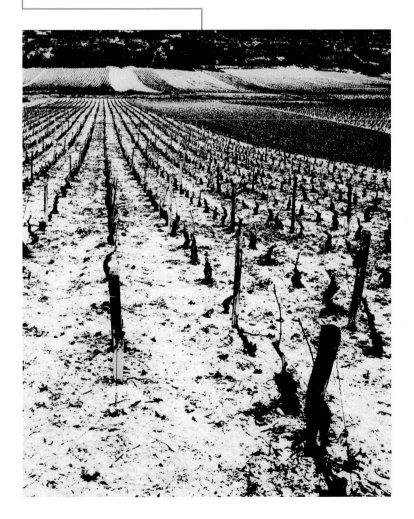

> **"I find wine country a very satisfying landscape to photograph because the vine planting imparts a strong sense of order and pattern"**

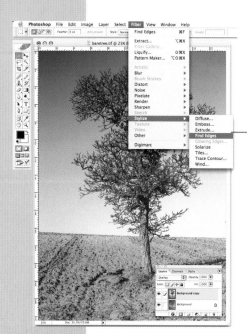

Find Edges

This filter found in Filter>Stylise creates some very interesting and attractive effects but although its sketch-like quality is initially appealing I prefer to use it in conjunction with other effects.

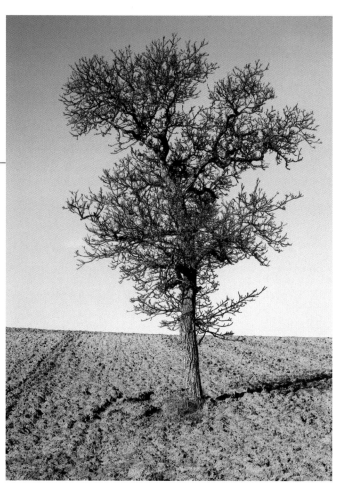

Bare Tree

I spotted this ;one tree as I drove through the French countryside in February. I have a fondness for isolated trees and winter is a fruitful time for shots like this because the lack of foliage allows the wonderful shapes and textures of the trunks and branches to be displayed. I chose a low viewpoint to place the tree against the blue sky and from an angle which showed its best aspect. I shot it first as a landscape shape to emphasise its isolation but also thought that a more tightly framed upright might have more impact. I was quite pleased with the captured image but thought that it might be interesting to create a more graphic quality. The result you see here was very simply achieved. I made a duplicate layer from the captured image and applied the find edges filter to this, the top layer and set the blend mode to Overlay. After flattening the image I adjusted both the density and contrast using Curves.

The Key To

The key to using effects like find edges is to look for qualities within the image which can be enhanced or accentuated by the effect and not allow it to become the dominant feature of the picture. You need to be sensitive to the interaction between the image and the effect being applied.

Rusty Pump

My first step with this image was to make a duplicate layer to which I applied the find edges filter and setting the blend mode to Multiply. The next stage was to make another duplicate layer from the background (captured) image and make this the top layer. To this image I used the process described on page 48–49 to create a sort of scraper board effect. I set the blend mode to Darken. After flattening the image I used Curves to make the image both a little less contrasty and lighter.

original shot

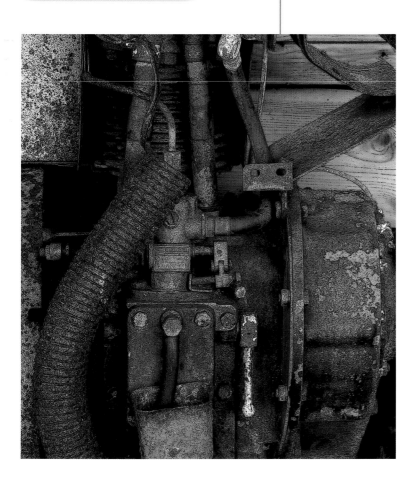

> **"The Find Edges filter creates some very interesting and attractive effects especially used in conjunction with other techniques"**

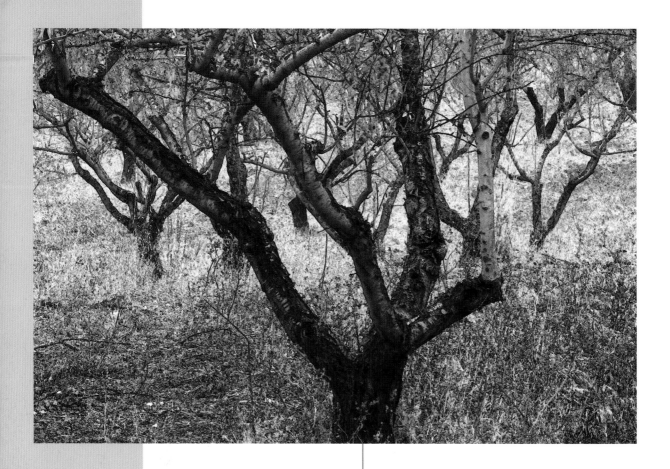

Bare Trees

I don't believe that filters and special effects can make a poor picture anything more than a poor picture with a special effect. However, I must admit that on occasions I've taken a shot which has been disappointing and then found that using a special effect has turned what made it disappointing originally into something quite interesting and striking. This shot of bare trees did not work because it was simply too messy and untidy but the use of the Find Edges filter has made a virtue of this fault.

I made a duplicate layer of the captured image to which I applied the Find Edges filter setting the blend mode to Soft Light. I used Curves to make this layer more contrasty and darker.

Then going to the background layer (the captured image) I used Hue and Saturation to make the colour richer and stronger. After flattening I used Curves to make a final adjustment to the image's density and contrast.

One of the advantages of digital capture over film is the lack of grain but many photographers in the past have used film grain very effectively as a creative device. It can be added to a digital image as Film Grain in Filter>Artistic or as Noise using the sliders to vary its size and intensity.

> **"I was pleased with the image but felt it would be more atmospheric and threatening if I added some grain"**

Black Sea

This shot was taken on a beach in the Costa de Sol during the winter on a very stormy evening. The beach and sky were actually this dark, the former is volcanic and not the white powder sand of the Caribbean. I chose a viewpoint close to the incoming surf and waited for a surge before shooting.

Although the sky was dark it was featureless and had no tonal variation so I added another sky from my collection in the way described on pages 66–67. I was pleased with the image but felt it would be more atmospheric and threatening if I added some grain. There is a choice in Photoshop of Film Grain found in Filter>Artistic, or Noise found in Filter>Noise and I opted for the latter. The problem with adding enough noise or grain directly to the image to be effective is that it degrades the image so I prefer to make a duplicate layer and apply the noise to this. I can then use the Opacity and Fill sliders to control its effect. After flattening the image I made it more contrasty and darker using Curves.

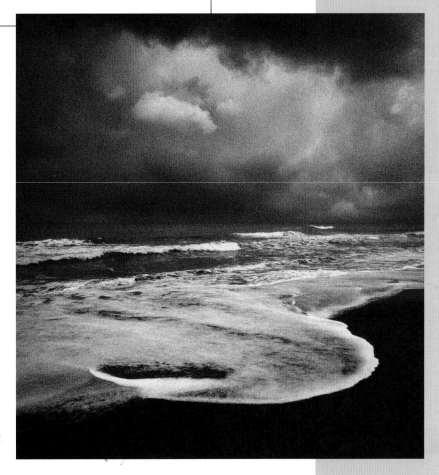

converting to monochrome

There are a number of ways of converting to monochrome, the simplest is to go to Image>Mode and select Grayscale. This method discards all of the image's colour information and you forfeit the ability to use this as a means of altering the tonal rendition of the image.

Going to Image>Adjustments and selecting Desaturate will also render the image as a monochrome, but will still leave you with the opportunity to introduce a colour tone if required.

Using the Channel Mixer is a method which allows you to have considerable control over the tonal rendition of a monochrome image in a similar way to using colour filters when shooting with B/W film, but with far more flexibility.

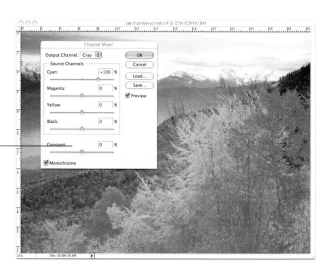

The Channel Mixer is found in Image>Adjustments and by clicking the Monochrome box the image is displayed in monochrome. By using the sliders you are now able to make colour layers in the image either lighter or darker. Setting the Blue slider to a minus value will make a blue sky in the image much darker, similar to the use of a red filter with B/W film; while setting the Green slider to a plus value will make green foliage much lighter in tone. With the right subject this can produce a result very similar to that created by infrared B/W film.

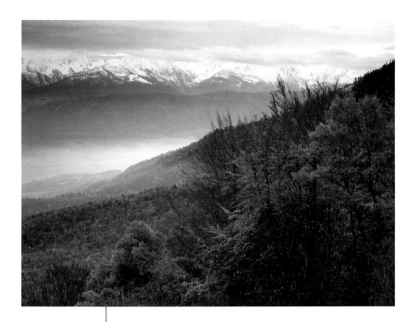

> **"**Using the Channel Mixer is a method that allows you to have considerable control over the tonal rendition of a monochrome image**"**

Isère Valley

I took this photograph on a misty autumnal morning from the Col du Granier on the road from Chambéry to the Chartreuse in the French Alps. Although the colour image was quite pleasing I thought it might have a more dramatic quality in monochrome. The first example shows the effect created by converting to Grayscale while the second was produced by using the Channel Mixer and adjusting the sliders.

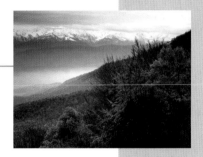

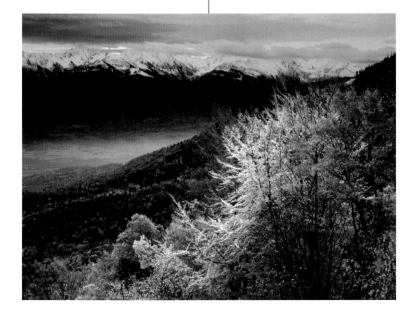

toning the image

There are several ways of adding colour to a black and white image. With an image in Grayscale mode you can convert it to Duotone or Tritone and select the ink colours from the colour picker to give you a very wide range of hues. With the image in RGB or CMYK mode the Hue and Saturation sliders will allow you to create a wide range of colours when you check the Colorize box. But both these methods only allow you to give the image a basic overall colour.

"Hue and Saturation sliders allow you to create a wide range of colours when you check the Colorize box"

Twin Gums

I photographed this twin tree in the Flinders range in South Australia on the edge of the outback. I was attracted by the shapes and textures of the contorted trunks and the fact they were so nicely lit. I chose a viewpoint which created the best separation between the two trees and showed a clear triangle of blue sky between them. I framed the shot so there was enough foliage to balance the more eye-catching tree trunks but not so much as to take away the emphasis. I used a polarising filter to make the sky a richer blue and to increase the colour saturation of the leaves.

I was quite pleased with the colour image but felt that it was perhaps just a bit too colourful and decided to change it to greyscale and add colour using the Tritone mode. I selected a chocolate brown for ink 1, a buttercup yellow for ink 2 and a pale lilac for ink 3. I then made an adjustment to the contrast and density using Curves and used the dodging tool to lift the highlights a little on the foliage and darker area of the trunks.

I was not entirely happy with this treatment as I felt the image looked a little muddy and I couldn't find alternative ink colours which overcame this. So I converted the original image to RGB and used the hue and saturation sliders to create the colour of the third image having checked the Colorize box. Again, I made a final adjustment to the image's density and contrast using Curves.

Gradient Map, found in Image>Adgustments, is another useful tool for converting a colour image to a toned monochrome. Using the Colour Picker, select the colours you want the image to have as the background and foreground colours choosing a very light and a very dark hue to create the gradient between highlight and shadow. When you open the Gradient Map panel the image will be displayed with the selected hues and you can fine tune the effect by using any of the density, contrast or hue and saturation controls.

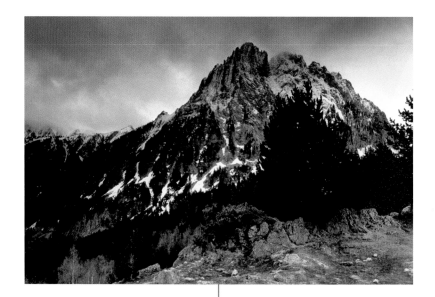

Mountain

This shot was taken in December in the Sierra del Encantada, the enchanted mountains of the Spanish Pyrenees on a day when it was overcast and the light quite soft and diffused. My viewpoint was chosen to enable me to use the outcrop of rocks as a foreground and I framed the shot to exclude some trees just to the right of the image area but with some sky included above the peak.

I converted the image to black and white using the channel mixer. I then selected the sky using the magic wand tool and made it a little darker using Curves, I then made a duplicate layer. With this layer switched off I used Curves to give the darker tones of the base layer a blue bias.

Going to the top layer I used the same method to create a sepia tint to the lighter areas of the image. Double clicking on the top layer thumbnail brings up Layer Options where I used the sliders to blend the two layers together until I obtained the mix of colour I wanted. After flattening the image I used Curves to make a final adjustment to the image's contrast and density.

With a colour image desaturated, or a black and white image in RGB or CMYK mode, there are many more ways of adding colour and of doing so in a way which allows a variation in hue within the image. You can achieve this by creating a digital version of the darkroom technique of split toning but with much more control. When I first started experimenting with the digital process I tried to emulate the effect of a monochrome lith print. The method I used was pretty simple but I still find it a useful way of achieving a split tone effect even if I never quite managed to create digital lith print.

Brown Field

Early winter can be a very fruitful time for landscape photography because the countryside is so rich with textures like freshly ploughed fields and bare-branched trees. This shot was taken in early November as I drove through central Spain. It was the texture of the field and the shape of the patches of pale grasses which caught my eye and I found a viewpoint where they were nicely aligned, framing the image so that only the most telling elements were included.

The original capture contained largely just brown and white hues and I decided to convert the image to black and white and add my own colour in order to simplify the picture and give it more impact. I used Select>Color Range to isolate the darkest tones and then used the Fuzziness slider to increase the selection until about half the image was selected. Using Curves I gave this area of the image a bluish tint and then Inverted the selection. By the same means

I then created a reddish sepia hue with the lighter tones of the image. Having removed the selection I made a final adjustment to the density and contrast of the image using Curves and tweaked the colour using Hue and Saturation.

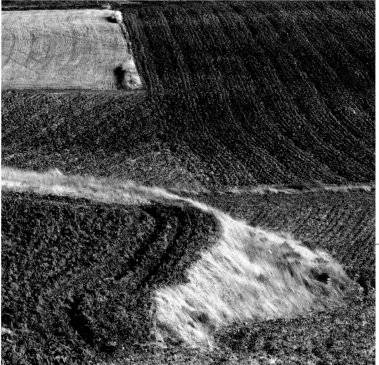

"I decided to convert the image to black and white and add my own colour in order to simplify the picture and give it more impact"

combining images

The Layers facility in image editing programs makes
it possible to combine two or more images with
considerable ease and gives you the ability to make
changes and go back to the originals at any time.

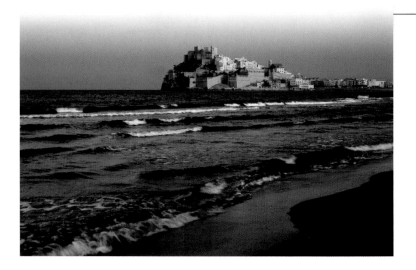

I've always enjoyed the process of blending images together
but with film the process was always been hit or miss and very
limited. One of the things I did occasionally in the darkroom
was to add a more interesting sky to a landscape image and
there are a number of ways of doing this in programs like
Photoshop.

Peniscola

The fortified town of Peniscola is in Eastern Spain to the south of Tarragona and was one of the locations used for the movie, El Cid. I arrived in late afternoon when the sun was quite low in the sky and mellow in quality creating a nice effect on the town and the sea. I chose a viewpoint which enabled me to use the incoming surf as a foreground and, using a wide-angle lens, framed the image to include a large area of the sea and sky as I wanted to show the splendid setting of the town.

The sky was a bit disappointing as there were **no clouds** and some atmospheric haze had given it a less than appealing colour. I decided

to add a **different sky** and from my collection selected one which had a similar colour quality and looked as if it would be compatible. Having adjusted the levels of the sky image I copied and pasted the image of the town onto a layer above the sky. With the two images in position I changed the sky colour of each a little until they more or less matched. I next made a mask of the town image and using a brush set to a low opacity I painted out the division between the two skies going as close to the buildings as I dare until they blended together convincingly. After flattening the image I made a final adjustment to the contrast, density and colour of the combined image using Curves.

❝I arrived in late afternoon when the sun was quite low in the sky and mellow in quality creating a nice effect on the town and the sea❞

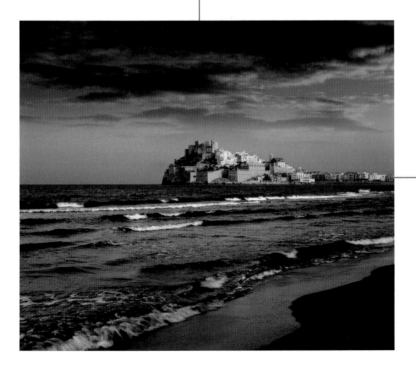

> **"It is easiest by far, and more likely to be convincing, if the object to be copied is clearly defined from the background"**

Another method of combining two or more images is to select a specific area of one and past it onto another. There are various methods of making the selection including some specialised software which can isolate very fine detail like hair from a background but it is easiest by far, and more likely to be convincing, if the object to be copied is clearly defined from the background.

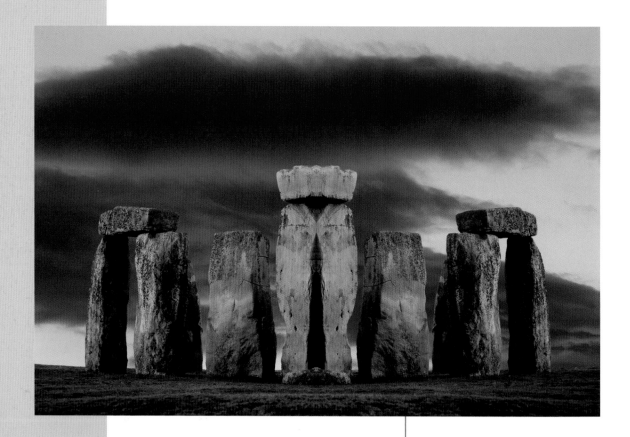

Stonehenge

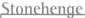

Luck was going my way on this visit to Stonehenge as it was almost deserted and there was a nice light from the evening sky. The sky itself was featureless but dark and quite atmospheric. I chose a viewpoint which created good separation between the tones and framed the image to include the most balanced area of the scene.

I was quite pleased with the captured image but I thought it would lend itself rather well to being 'mirrored'. To do this I cropped the image through the centre at a spot where I could visualise it being joined easily. I then added extra canvas on this side to the exact size of the width of the cropped image. Using pixels as a measurement is the best way of doing this. I next selected the extra canvas area using the magic wand tool and inverted the selection in order to copy the remaining stones. The next step was to re-invert the selection and then paste the copied stones into the extra canvas. All that remained was to flip this half of the image, which was now on a separate layer, using Edit>Transform to obtain a perfectly joined mirror image. I then flattened the image.

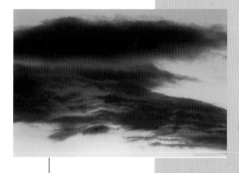

To go one stage further I found a sky I thought would combine well with the stones and established this as the background image. Going back to the stones image I selected the sky area using the magic wand tool and then inverted the selection. I applied a small amount of feathering, just 2 pixels, and then copied the stones. I next pasted this image onto the sky adjusting its size and position using Edit>Transform. If there is an edge visible around the pasted image you can go back to the selection and contract it by a pixel or two and you can also go to Layer>Matting and apply one or two pixels of Defringe. Finally I flattened the image and made a final adjustment to the density, contrast and colour using Curves.

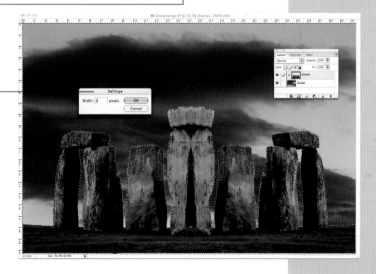

"Using the masking tool to remove the elements you don't want closely resembles the montage printing technique used by darkroom workers**"**

The layers masking facility in image editing software makes it possible to combine two or more images in a multitude of ways. With some montage images it is easier and often more effective to copy and paste a number of roughly selected images onto layers and use the masking tool to remove the elements you don't want than it is to make precise selections before copying them. This closely resembles the montage printing technique used by darkroom workers but with much more control and, of course, the ability to go back one or more stages at any time. It's always worth experimenting with different blend modes. I find their effect unpredictable as so much depends upon the contrast, colour and density of both the layer being worked on and the layer below as well as the nature of the image.

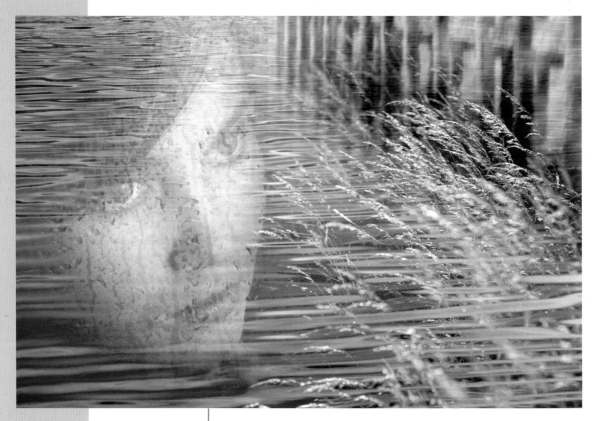

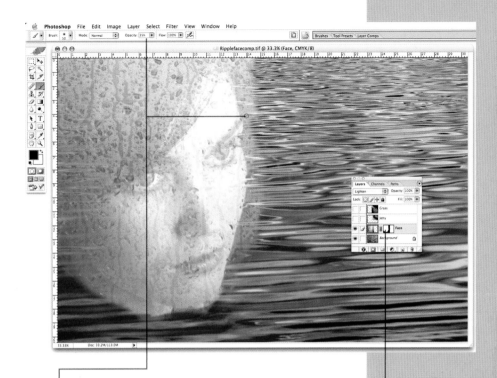

Reflections

This picture was a combination of four photographs with the background image a shot of ripples on a lake. The aim was to create a picture which conveyed a sense of peaceful pensiveness. The other three images of a blurred jetty, a portrait and some wind-blown grasses were all roughly selected and copied before being pasted onto separate layers above the ripples one at a time. I established the portrait as the second layer and used Edit>Transform>Scale to adjust its size and position. With the blend mode set to lighten I made a mask for it and using a brush set to 100% opacity I painted away the hard edges of the portrait. Switching to a progressively lower opacity, I continued brushing closer to the area I wanted until I achieved a gradual blend of this image into the water. I placed the jetty image on top of this with the blend mode set to luminosity, and adjusted the size and position. After making a mask I followed the same procedure as before. The final layer with the grasses image was set to lighten, otherwise the same method was followed.

adding edges

No matter how stunning a photograph, or how good
the quality of a print, the image will benefit from
good presentation. You can do this with prints by
using bevel mounts and frames but it's also possible
to make the print itself look more finished using
image editing software.

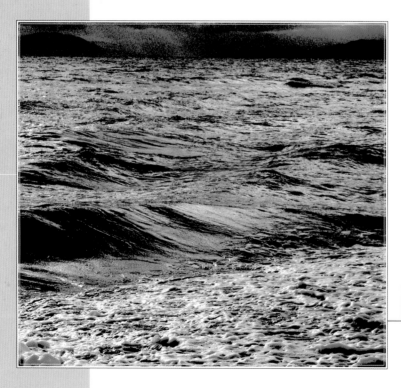

Rough Sea

For this edging effect I first drew
a selection close to the edge of
the image using the Marquee tool
and used Edit>Stroke to draw a
fine yellow line, the colour being
selected from the colour picker. I
next increased the canvas size by
a few pixels all round to add the
band of white. Finally, I selected the
whole image and used Edit>Stroke
to draw a black line around the
outside of the image. The exact
number of pixels you use to stroke
the selection and add canvas
depends upon the size of the
image and the effect you want to
create. It's worth experimenting
until you arrive at an effect which
looks right for the picture.

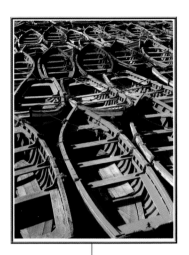

Of course if your images are to be displayed on the web, or sent by email, using image editing software is the only option. There are so many ways of adding an interesting edge to your images that your imagination becomes the only limiting factor.
But it's best not to become too carried away as you don't want to distract attention from the image or create a gimmicky appearance.

> **"No matter how stunning a photograph it will benefit from good presentation"**

Blue Boats

To create this effect I began by adding some extra canvas and then opened a new layer above the image. On this layer I drew a selection using the Marquee tool a little bigger than the image and stroked this with the colour from the picker which was sampled from the image. I then used Layer Style in Layer to create the bevel effect. The advantage of making this frame on a separate layer is that its size and position can be adjusted using Edit>Free Transform afterwards if necessary.

Striped Rock

I cheated a little for this effect because I used an edge created in the darkroom and photographed it. It was made by roughly filing away the sides of the negative carrier and allowing this to print around the image, a popular technique with fine-art photographers. You can buy software which emulates this kind of edge but for my taste they are not very pleasing or convincing. Alternatively it wouldn't be difficult to paint some like this if, unlike me, you can use a brush effectively. I simply photographed the print and erased the darkroom image replacing it with my digital one. The method is to place the photo edge on a different layer above the print and then use Edit>Free Transform to adjust its size to fit. As the edge was black I then used Curves to create a colour which toned with the image.

gallery

Wooden Jetty

Capture

 I came across this peaceful scene while driving along the edge of Lake Coniston in Cumbria early one autumn morning. The water was fairly still and there were only slight ripples which created some interesting reflections. I spent a while taking some straightforward shots using various viewpoints and framing but this seemed the best combination.

Although the resulting image was quite pleasing I felt it was a bit ordinary and cliched and decided to experiment with blur caused by camera movement to see if it might add a little excitement to the image.

One of the big advantages of shooting digital over film is that you can see the results immediately and with this technique it allows you to vary the shutter speed together with the direction and speed of the camera movement until you get the effect your want. I made about a dozen exposures before arriving at this result.

Enhance

The captured image, when downloaded, was pretty much how I'd visualised it and I only needed to make small adjustments to the contrast and density using Curves.

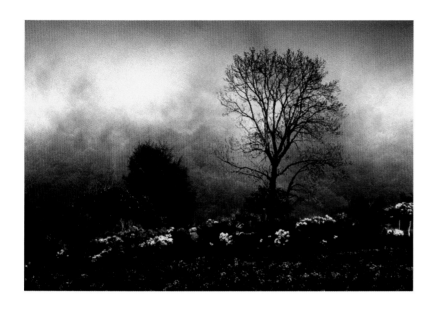

Tree in the Mist

Capture

This scene was photographed in the early spring in the Auvergne region of France. The early morning mist had just begun to clear and I liked the way the tree had become isolated from the background by the mist and the interesting tonal graduation this had created.

I chose the viewpoint which made the tree stand out most clearly and framed the image so that it was placed along a line about one third of the way from the edge, as I felt this created the most pleasing balance.

Enhance

Although potentially atmospheric, the colour image was, predictably, rather disappointing. The colour of the captured image was uninteresting and rather wishy washy. Overall the image lacked atmosphere and impact.

For this reason I decided to convert it to monochrome. I did this by using the Channel Mixer in the way described on pages 60–61, adjusting the sliders to obtain the maximum separation between the tree and the background and the richest range of tones in the swirling mist. I then adjusted the density and contrast using Curves and lightened the foreground a little by using the Dodging tool set to the mid tones at a low exposure.

I introduced the colour element by using the Gradient Map in the way described on page 63, selecting a chocolate brown for the darker tones and a pale greenish gold for the lighter ones. I made a final adjustment to the contrast and density using Curves and then added a small degree of noise, using Filter>Noise>Add Noise, to emulate film grain and add a little texture to the image.

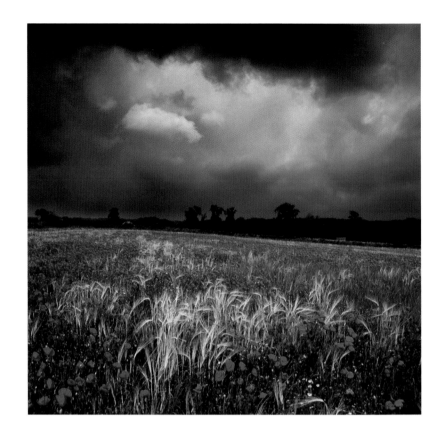

> **"**Although I was quite pleased with the resulting picture I felt it would be improved by having a more interesting sky**"**

Summer Storm

Capture

I was travelling in the Cher region of France when I spotted this meadow strewn with poppies. It was a heavily overcast day with dense grey cloud but periodically it would thin, allowing weak sunlight to seep through. This created very bold colour saturation which was heightened by the dark sky behind. I chose a viewpoint which placed clumps of both grasses and poppies in the close foreground and framed the shot to include some sky, equal to about one third of the image area.

Enhance

Although I was quite pleased with the resulting picture I felt it would be improved by having a more interesting sky. I have a collection of skies and one of them pretty well matched the tone of the sky in the captured image. I added extra canvas to the base of the sky image, enough to accommodate the meadow, which I copied and placed on top as a separate layer, using the method described on pages 70–71.
I then made a mask of the meadow image and, using a large brush set to about 15% opacity, began to paint away the dividing line between the sky of the meadow and the underlying sky making small adjustments to the density and colour of each until the join was invisible. I then flattened the image and made a final adjustment to the density and contrast using Curves.

Old Window

Capture

I found this derelict cottage while travelling in the Thierache region of France and was attracted to the colour and texture of the ancient tiles and wood work. I chose a front-on viewpoint, using a long-focus lens from a distance to minimise the effect of perspective, and framed the image to exclude all but the most important details.

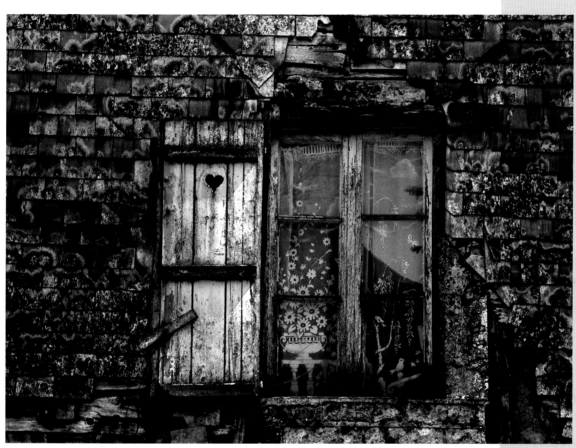

Enhance

I've combined three images here but all are placed in register with each other using Layers. I began by making a dupe layer of the captured image which I then desaturated and colourised using Image>Adjust>Hue and Saturation to create a slightly sepia tone and set the Layer Mode to Multiply. This made the image stronger and richer and added a more interesting colour quality.

I next made another dupe layer from the captured image and placed this on top. I used Filter>Stylise>Find Edges to create an outline of the image structure that I then desaturated and made more contrasty using Curves. I set this layer to Multiply mode. I made slight adjustments to the density, contrast and colour saturation of each layer until I was happy and then flattened the image.

Pylons

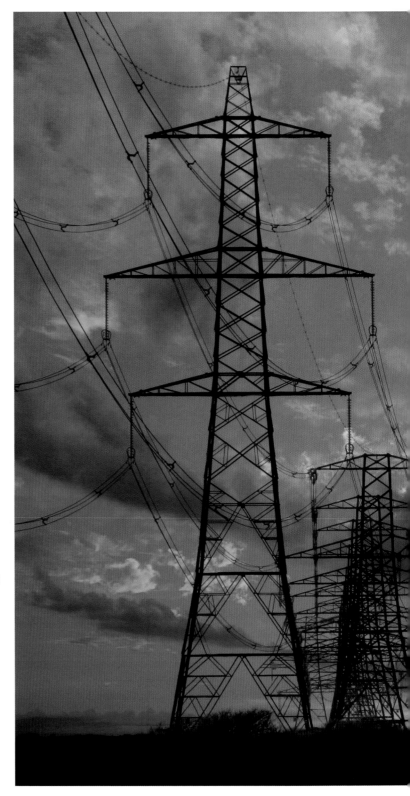

Capture

This impressive array of pylons are close to Dungeness power station and a road goes conveniently under them which makes finding a good viewpoint a fairly simple matter. My choice was based on being able to see as far along their path as possible and at the same time have a nicely balanced arrangement without being too symmetrical. I found that moving just a meter or less from right to left, and vice versa, made a big difference to the composition and this, in combination with a zoom lens, gave me a number of options. I shot several of them but this was the one I liked best.

Enhance

The pylons were photographed on a dull day with an almost white sky and I added the sunset by increasing the contrast of the pylon image and then copying and pasting it onto the sunset. By setting the Blend Mode to Multiply I obtained the effect you see here and after flattening the image I made slight adjustments to the contrast and density of the combined image. This technique can be applied to most subjects which are essentially in sillhouette and is a good solution to the problem of seeing a stunning sunset but not being able to find something interesting to place in the foreground. No matter how impressive a sunset might be it will invariably produce a more striking photograph it there is a positive focus of attention.

Plastic Bales

> **"**There is something slightly mesmeric about a pattern and this can often be exploited very successfully in a photograph**"**

Capture

I wanted to take this picture for three main reasons. Firstly, I have a liking for plastic which I think is because of its reflective quality and its ability to create a subtle range of tones and I seem particularly drawn to plastic wrapped hay bales. The second reason is the element of pattern which invariably creates a strong sense of order within the image together with a tendency to draw the viewer's eye into the image. There is something slightly mesmeric about a pattern and this can often be exploited very successfully in a photograph. The third reason was the lighting which was perfect for this particular subject. It was a bright but overcast day with most of the light being directed from the sky which produced a very pleasing plastic quality and a wide range of tones without any bleached out highlights or overly dense shadows. I used a long focus lens to frame the image from a fairly distant viewpoint which had the effect of compressing the perspective and emphasising the pattern.

Capture

I photographed this plantation of trees during a winter visit to Spain on a very overcast day when the light was so diffused that barely any shadows were formed. My viewpoint was from the roadside which was raised above the field of trees and this allowed me to shoot down and use the leaf-covered soil as a background. I spent some time exploring viewpoints in order to find a position in which the trees were placed in a balanced and unconfusing way with each other. I made a half a dozen or so exposures from different viewpoints often only moving a few feet from side to side but this was the image I preferred.

Enhance

The resulting capture was predictably very low in contrast which was easily corrected by using auto levels but the image still lacked bite. I made a duplicate layer to which I applied the find edges filter and set the blend mode to multiply. This produced a result much closer to how I'd visualised the image but it still needed a little more oomph. This was achieved by using Curves to increase the contrast and density of the duplicate layer together with hue and saturation to boost the very subtle colour of the base layer, the original capture.

Tree Trunks

Slender Trees

"I realised that tilting the camera to one side would create some interesting diagonal lines which would give the picture a more dynamic quality **"**

Capture

An image which contains a strong diagonal tends to have a quite vigorous and eye-catching quality. This is a useful compositional device which can be applied effectively to some subjects. These rather sparse trees caught my eye as I was travelling through a region in the Mediterranean which had been decimated by fire. I suspect that the lack of branches and loss of bark might well be as a result of these fires but I thought that the resulting effect had given the surviving trees a rather slender and elegant quality.

The sky was also a factor as the light cloud had created some pleasingly soft, smoky tones which I thought provided a perfect background to the trees. Because of the sky, and the fact that the ground was strewn with bushes which had been rendered to charcoal, a viewpoint close to the trees and a steeply tilted camera with a wide angle lens was unavoidable. It was at this point that I realised that also tilting the camera to one side would create some interesting diagonal lines which would give the picture a more dynamic quality.

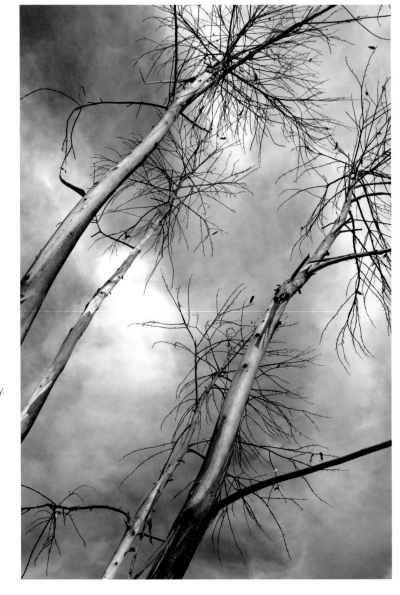

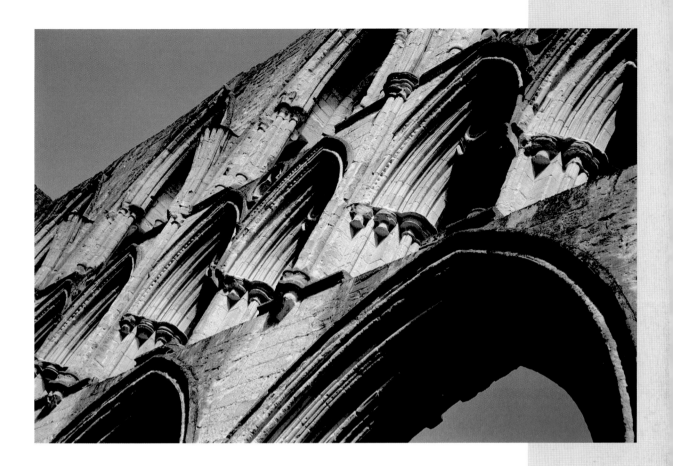

Abbey Windows

Capture

I've used a similar approach to the "Slender Trees" image in this shot of Rievaulx Abbey in Yorkshire, UK, shooting with a wide angle lens from a quite close viewpoint and tilting the camera both steeply upwards and to one side to create diagonal lines. The subject appealed to me partly because I was lucky enough to arrive there at a time of day when the light was exactly at the right angle to reveal both the texture of the ancient stone and the details of the finely carved windows.

Enhance

The resulting capture was quite pleasing but a little bland and I felt it lacked the eye-catching quality which I thought the diagonal lines would provide. I decided to give the image a bit more bite by making a duplicate layer and using the threshold facility to create a pure black and white image. By using the sliders I adjusted the level so that most of the image was white and only the very darkest tones were rendered as black. I then set the blend mode to multiply and made a final adjustment to the image by going back to the base layer, the original capture, and increasing the colour saturation a little.

Rocks and Sky

"I shot the picture from a fairly close viewpoint with the camera tilted a little using a wide angle lens which has made the rocks appear larger than they are in reality"

Capture

There's a beach in Devon which I like to visit whenever I visit my son, Jules, who lives nearby. It's a small beach sheltered by rocks on either side with a long finger of sand when the tide goes out. The rocks are the attraction for me and I've taken numerous pictures there, although I think that Jules tends to regard it as his own beach. I took this shot on a bright but fairly cloudy day when the bank of rocks was nicely lit. Bright, unobscured sunlight creates a rather harsh and contrasty look and the lovely texture and patterns in the stone becomes obscured. I shot the picture from a fairly close viewpoint with the camera tilted a little using a wide angle lens which has made the rocks appear larger than they are in reality. I did not include much sky in the original capture as it was a bit pale and featureless. The resulting image was a bit disappointing simply because I felt that the rocks alone were not interesting enough and I decided to add another sky.

Enhance

There are several ways I use to add a sky. The method I prefer is to blend the new sky with the existing one using a mask but this would not work here as the sky I wanted to add was very much darker than the existing one. But the outline of the rocks against the light toned sky was very well defined and I thought the best approach was to select the rocks using the magic wand tool. By gradually reducing the tolerance setting and gradually enlarging the image, eventually to 200%, I was able to create a fairly precise selection of the sky area and the outline of the rocks. I then inverted the selection to isolate the rocks, applied a couple of pixels of feathering and contracted the selection by a similar amount. I then simply copied the rocks and pasted them onto the new sky and adjusted the contrast and density of each layer before flattening the image.

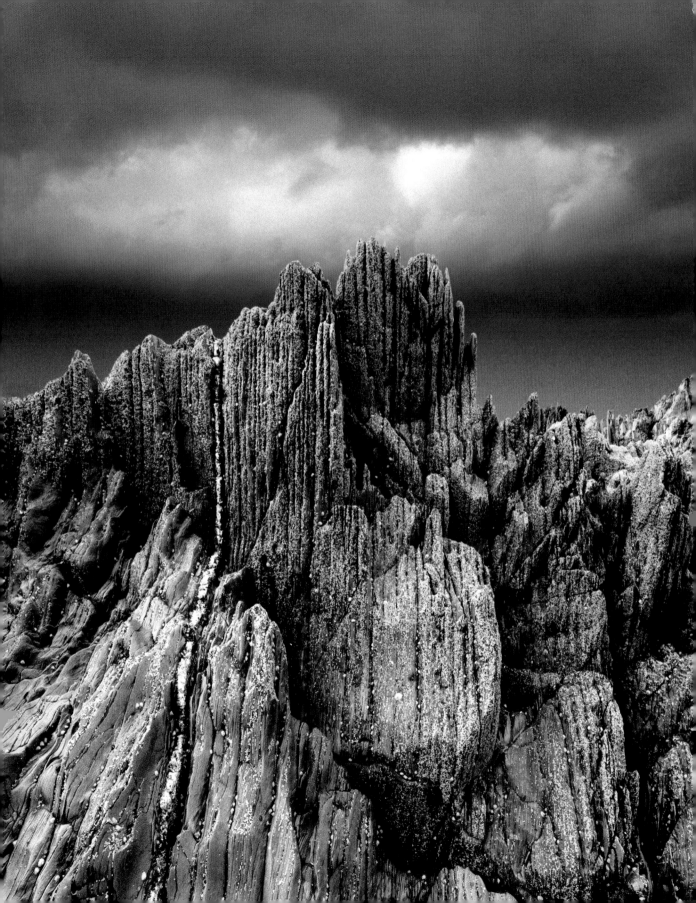

Blue Window

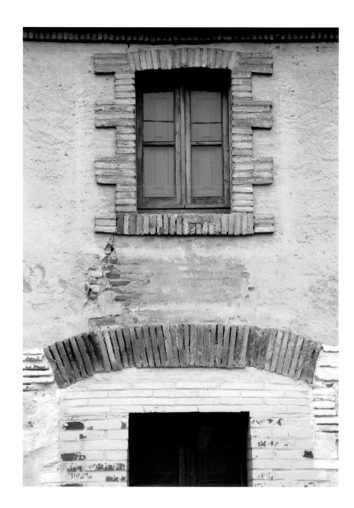

> **"I tend to prefer images that are tidily organised and have an essential simplicity about them"**

Capture

Among the subjects I seem to be drawn to are doors and windows and I have accumulated quite a collection over the years. I think one reason for this is that I tend to prefer images that are tidily organised and have an essential simplicity about them. As a rule this type of picture does have a quite strong visual impact and is easy to look at. The down side, perhaps, is that they can be a bit superficial and once they have the viewer's attention it can wane fairly quickly. A rectangular shape in an image is also an eye-catching element, as too are circles and triangles, and there is something quite satisfying about a subject which echoes the shape of the image's frame.

I spotted this old window in a derelict building beside a busy road in northern Spain. I think it must have been a small factory or workshop, and I loved the colourful brickwork around the window and the decoration below it. The building was very close to the road and the only way I could shoot the picture was from the opposite side using a long-focus lens to frame the area I wanted to include. It was more difficult than you might think as vehicles passed by every few seconds in both directions obscuring my view and I was using the camera's mirror lock and delayed action to eliminate the risk of camera shake. It took several exposures before I was able to capture an image free from traffic.

Capture

 Also shot in Spain was this picture of another very derelict building where only parts of the walls remained. It appealed to me because of the blue paint on the flaking plaster walls inside. I took up a viewpoint which showed one of the windows square on and a nice blue wall immediately behind it. My first shot was from a relatively close viewpoint and I set a small aperture to try to show both the window frame and the wall behind in sharp focus. The distance between them was too great for them both to be perfectly sharp and so I had another thought. I took up a much more distant viewpoint and used a long focus lens at full aperture so that the window frame was sharp but the wall behind quite blurred and thought that this created a slightly ambiguous, almost abstract quality.

Window
Frame

Sand Swirls

Capture

I have a liking for images which have an element of abstraction so the viewer is not immediately aware of what he or she is looking at. This can be achieved either by the choice of subject matter or the way in which the picture is composed, or a little of both. This shot was taken on a beach near my son's home where at low tide a small stream crosses the beach and deposits some darker silt into the ebbing water. This leaves a variety of curious and appealing patterns on the lighter coloured sand. I have to say I'm intrigued by this effect and have spent many a happy hour during the past few years shooting the occasional picture. This is one of my efforts shot on a very wide-angle lens with the camera looking almost straight down. I found that using a polarising filter helped to increase the contrast between the dark soil and the light sand.

Enhance

I decided this picture would work well as a tinted monochrome and used the channel mixer to further separate the light and dark tones. My aim was to produce a pseudo lith effect and the first step was to make a duplicate layer. With this layer switched off, I used Curves to give the darker tones of the base layer a bluish tint and then, returning to the top, duplicate, layer checked the Colorize box in Hue/Saturation to give a pinkish sepia hue. Double clicking on this layer brought up Layer Options and I used the sliders to blend the two layers together to achieve the effect I wanted.

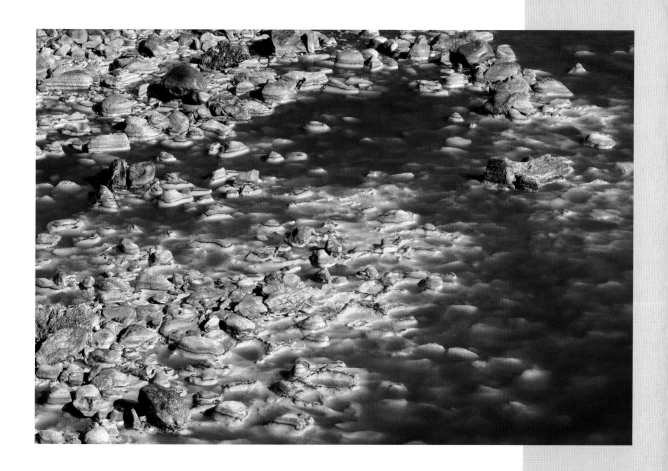

"I used a long-focus
lens to isolate a small
area and framed the
image to include
enough of the stones
to establish a neutral
colour in the picture**"**

Rio Tinto

Capture

Often nature provides its own curiosities and abstraction and this image is a very straightforward capture of a river in the south of Spain which is coloured by the result of minerals leeching into the water from the abandoned mines of Rio Tinto. At this point the river is quite narrow and the shot was taken from a small bridge which crosses it enabling me to look down at the river bed. I used a long-focus lens to isolate a small area and framed the image to include enough of the stones to establish a neutral colour in the picture. This has helped to emphasise the curious red tinted water and without it the picture may well have looked as though it had a particularly bad colour cast. I used a polarising filter to increase the colour saturation of the water and to reduce the reflections in its surface.

Autumn Leaves

"My ideas tend to come fom seeing individual images first and then visualising how they might work together"

Capture

There's a shrub in my garden which has leaves that go through an astonishing progression of colour changes over a period of several weeks as autumn develops. I kept a close eye on its progress last year and when I saw this particular leaf I felt obliged to photograph it. I placed on the light box which I used to view transparencies so that I would have a pure white background with no shadows under the leaf. The surface of the leaf was lit by light from a window and I simply moved the light box to a position where the background light was strong enough in relation to the window light to provide a white background without being bright enough to create flare. I used a macro lens to fill the frame with the leaf and mirror lock combined with delayed action release to ensure the image was free from camera shake.

Enhance

Although I thought the image of the leaf was quite striking on its own I thought I would explore the possibility of using it in a composite. There's no doubt that the best way to approach making composite images is to have an idea first and then shoot the images necessary to create it. But I find it very hard to do that and my ideas tend to come from seeing individual images first and then visualising how they might work together.

Selecting the leaf using the Magic Wand tool was easy as it was so clearly separated from the white background. I then inverted the selection before copying and pasting the leaf onto the forest scene. I then made a duplicate layer of the leaf image and used Edit>Transform>Scale and Edit>Transform>Rotate to place the second leaf where I thought it created the best balance.

Rusty Chain

"It can be surprising
just how many picture
opportunities there are
virtually under your nose**"**

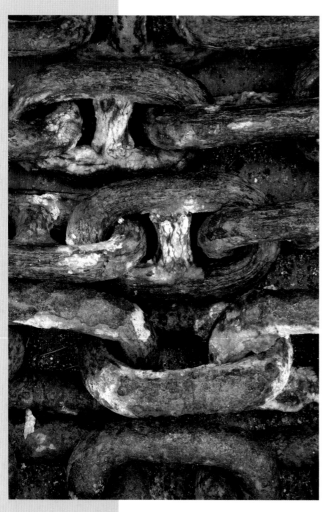

Capture

 I'm sure that most keen photographers will
have experienced occasions when it seems
very difficult to find something interesting to
photograph, as I know I have. When looking for subjects
there's a natural tendency to do so at a distance. I'm sure
that the vast majority of photographs are taken of subjects
which are probably ten meters or more from the camera.
If landscape photography is your special interest then
your eye is almost certainly focused at greater distances.
It might surprise you just how many picture opportunities
there are virtually under your nose and once you refocus
your eyes to, say, less than a couple of metres away many
more possibilities become apparent. A further advantage
of this type of subject is that the lighting criteria tends to
be a lot more flexible than for subjects like landscapes.

I call pictures like this shot of a rusty chain 'found still
lives'. It was laying on a quay at a small fishing port on
the Isle of Barra and, being naturally drawn to rust and
decay, I thought it might make an interesting shot. I used
a normal zoom lens with a close focusing facility as the
camera was about one meter away from the chain. My
viewpoint was almost directly above the subject and I
used a tripod to allow the use of a slowish shutter speed
and a small aperture to ensure adequate depth of field.

Capture

 Like "Rusty Chain", this piece of rusting metal was also photographed on the Isle of Barra. I came across it while indulging in a bit of beach combing on one of the pristine beaches there. It appealed to me because of its nice shape, the combination of the rust colour and the dusting of sand. This shot was also taken with the camera aimed straight down at the subject using the same lens and method as the chain image. I did remove just a little of the sand where it had covered the metal too densely with a feather I found nearby.

Enhance

 I was quite pleased with the captured image but thought that it would be improved if there was a little colour contrast between the background and the metal. To do this I selected the background of sand using the magic wand tool and feathered it by just a couple of pixels. Using Curves I then gave the sand a bluish colour cast. I'm aware that it now does not match the colour of the sand on the metal but I don't think that this is something which looks too odd and, in any case, feel that the improvement justifies it. I put it down to artistic licence.

Rusty Fragment

"I'd shot a few images with the road empty but felt that there would be a heightened sense of scale and distance if there was a car somewhere on the road"

Capture

This long, straight hump-back road is in California's Death Valley and I was driving one of the few cars that I'd seen for some time. When I reached this stretch I thought that the shine on the road created by the bright sky above the mountain heralded the possibility of a picture. In order to have the road receding directly into the distance, my viewpoint had to be the centre of the road. This was not as hazardous as it might have been as the road was so quiet. But I had to wait there for a considerable time before a car appeared. I'd shot a few images with the road empty but felt that there would be a heightened sense of scale and distance if there was a car somewhere on the road. Having lined up my camera carefully and framed the image as I wanted, using a long focus lens. It was almost inevitable that the only vehicle to appear for a long time was from behind me and I had to move my camera and tripod to the side of the road until it had passed. It was then a rather frenzied rush to realign it before the car had travelled too far away for my picture.

Enhance

Apart from the highlighted road, the image was rather flat, both tonally and in terms of colour as the backlighting had subdued the little colour there was in the scene. The mountain was virtually silhouetted and the scrubland to each side of the road a sort of muddy brown colour and not very attractive. The solution was to add a different sky which had some rich tonal gradation and this would add atmosphere as well. I have a collection of sky images and this one seemed to fit the bill.

I selected the sky area of the original capture using the magic wand tool reducing its tolerance and enlarging the image as I worked closer to the mountain's outline. I then inverted the selection and applied a small amount of feathering, just two pixels, and contracted the selection by the same amount. I then copied this and pasted it onto the sky, to which I'd added extra canvas at the base to accommodate the landscape.

I enlarged the combined image to 100% to check how good the outline was and discovered there was a small amount of fringing which I removed by going to Layer>Matting>Defringe and selecting two pixels. Once I was happy with this I adjusted the density and contrast of each layer until they were well balanced and then flattened the image. At this point I'd been working with the image in colour and I felt that it would be more striking in black and white so I used the Channel Mixer to obtain the maximum range of tones.

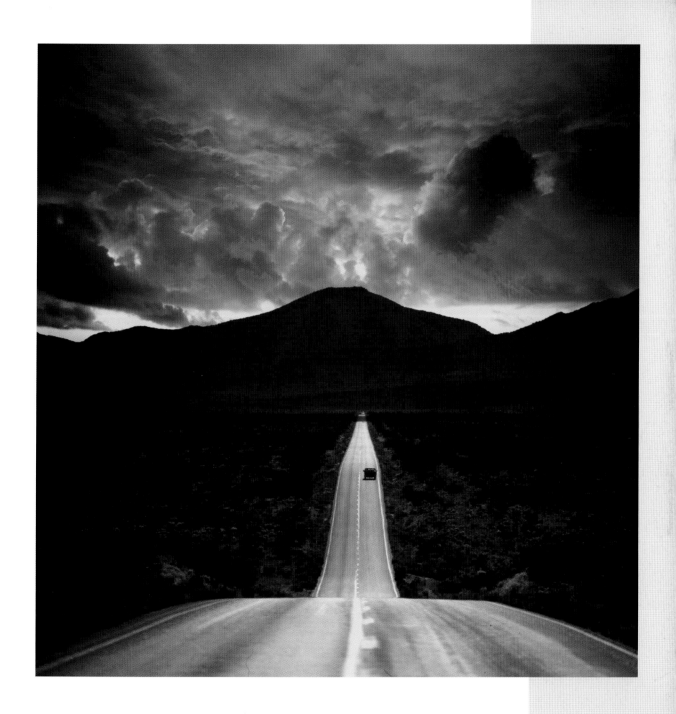

On the Road

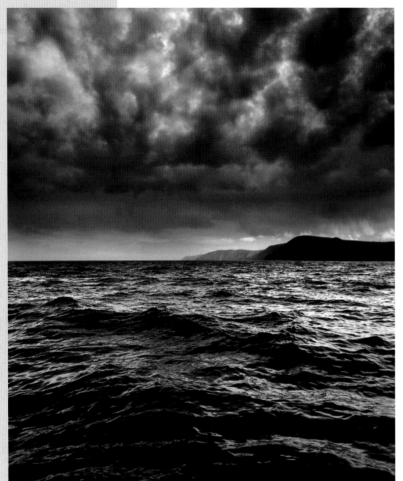

Capture

This picture was taken during a mackerel fishing trip off the north Devon coast. I'd only taken a small compact camera with me in order to capture the record-breaking fish which we were convinced would give itself up to us and had no thought at all of 'serious' photography. But the light on the sea made the fairly modest swell look quite threatening and also created a very pleasing quality. Although the light was bright enough to use a fairly fast shutter speed I waited until the boat reached the limit of its tilt before shooting, at the moment when there is little or no movement. Because I was using a wide-angle setting on the zoom lens the nearest detail of the water was quite close in the foreground and the slightest movement would have caused noticeable blur even at the 1/250 sec shutter speed I had set.

Enhance

The sky was quite light in tone and virtually featureless and consequently I'd only included enough of it in the frame to show the distant headland. Although as a shot of rough sea the image was quite effective I felt it needed to have more real impact and decided to add a more interesting sky. I also decided that I'd make no attempt to deceive and chose a sky which would draw attention to itself and create a slightly fantasy-like effect.

Because I'd cropped the top of the image quite tightly I didn't have much room to work with but using the Burning tool I made the sky as dark as I could at the top of the frame. I next copied and pasted the sky I'd chosen to add and placed it on a layer above the captured image, adding extra canvas. Next, I made a mask of this layer and using a soft-edged brush set to a low opacity I painted away until the two skies merged.

Rough Sea

Capture

The Isle of Barra in the Outer Hebrides has some of the loveliest beaches I've seen anywhere with fine, powder-white sand and clear turquoise water. One of the difficulties in photographing a beach is finding something to hold the image together, as no matter how stunning it is to look at sand, sea and sky are rarely interesting enough on their own. This curious formation of rocks was something of a godsend as not only did it provide an interesting and striking foreground but it also led the eye into the image very effectively and the plume of cloud flowing in from the sea added a final touch of drama.

Enhance

The captured image still needed a little work. I used the rectangular marquee to draw a selection from the horizon to the top of the frame and feathered it by 15 pixels and using Curves made the cloud both a little darker and slightly more contrasty. I next drew a selection around the foreground rocks using the Polygonal Lasso tool and feathered this by a similar amount. Using Curves I made this area lighter and increased the contrast. Using the Dodging tool I finally brightened some of the foreground rock detail a little further where needed.

Barra Beach

"The plume of cloud flowing in from the sea added a final touch of drama"

Gnarled Wood

Capture

 I'm sure that most photographers have places near their home which they go to on a fairly regular basis to look for pictures. I'm very lucky to have a beautiful woodland park less than a mile away which I visit from time to time. It suffered very badly in the hurricane of 1987. For several years there were piles of fallen trees which had been sawn up and the air was often polluted by the billowing smoke of countless bonfires. Fortunately one of the loveliest features of the park, a tree-lined avenue, was not unduly damaged and many of the very ancient trees, some little more than gnarled trunks and stunted branches, were left unharmed.

This shot is of one of the old trees, taken on a winter's day when there was some weak sunshine. Texture can be a powerful element in a monochrome image and weathered wood like this has great potential. I view subjects like this as landscapes in miniature and find them just as enjoyable and challenging to photograph as a spectacular view. But unlike a view, subjects like this need to be lit quite softly if the subtle tones of the textured surface are to be captured successfully. This area of the tree was on its shaded side, but even so the highlight on the right created by reflected light from the sunlit grass to the side is almost too bright. I used a long focus lens from a distance of about four or five meters to frame my shot in order to reduce the effect of perspective and to exclude the brightly lit background to the sides of the tree trunk.

Enhance

 In spite of the fairly soft lighting the contrast range of the captured image was quite high so I needed to use the dodging tool set to first the mid tones and then the highlights in order to lighten and brighten the left hand side of the wood. I used the channel mixer to render the image in black and white and then decided it would look more effective in sepia. I did this by going to Image>Adjustments>Hue/Saturation, checking the Colorize box and using the sliders to achieve the colour I wanted.

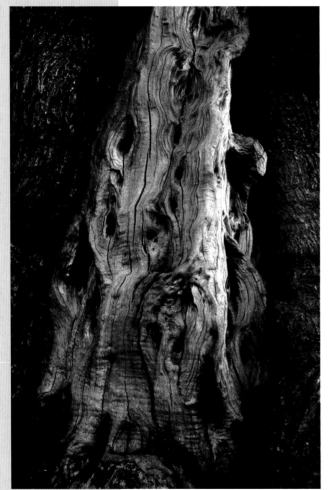

Birch Trunk

> **"I** opted to use flash to light the tree as an exposure for the ambient light would have made the background much lighter in tone**"**

Capture

I find there's something very appealing about silver birches, the texture and colour of their slender trunks has such a delicate appearance. This image is, I admit, somewhat minimalist and I'm not absolutely sure what it was exactly which made me want to photograph it, although I guess Freud might have ventured an explanation. It was shot in the wintertime on an overcast day and the interior of the wood was quite dark. I took the photograph from a distance of about five meters using a long focus lens set to a wide aperture as I wanted the background to be as unobtrusive as possible. For this reason I opted to use flash to light the tree, because an exposure for the ambient light would have made the background much lighter in tone. Even so, I needed to use the Burn tool to darken the background a little more and to subdue some of the remaining details.

Spanish Tree

Capture

For me, these trees instantly identify Spain. I photographed this one on the Castilian plain to the west of Madrid where thousands of acres of, largely, very flat land are used to grow wheat and other grains. This picture was taken in the late afternoon when the sun was getting quite low in the sky, which has created the tree's long, raking shadow and the well-defined texture of the soil. I used a long focus lens to isolate a small area of the scene and to enlarge the quite distant tree.

Enhance

The captured image was a bit disappointing as the 35mm format resulted in an area of sky at the top of the frame which was rather uninteresting and also had too much space at the bottom. This, of course, was easily overcome by cropping the picture to a more panoramic shape but I felt the image still lacked the appealing quality of the scene when I first saw it. The reason seemed to be that, in colour, the tones in the sky were a bit weak and the field was a similar tone. By rendering the image as black and white using the Channel Mixer, I was able to use the sliders to increase the red sensitivity. This made the soil a lighter tone as well as lightening the brightest part of the sky, while reducing the blue sensitivity made the cloudier areas of the sky significantly darker. The overall effect was to make the image punchier and more atmospheric and much closer to the memory I had when first seeing the scene.

"The overall effect of converting this image to monochrome was to make the image punchier and more atmospheric and much closer to the memory I had when first seeing the scene"

Sacré Coeur

Capture

This famous Parisian landmark must have accounted for many millions of films; it's the sort of sight that few people can resist photographing. The church is built on a fairly narrow terrace from where the ground dips steeply down to the streets below and there's little scope for photographing the front elevation from anything but a low viewpoint. This is one of those pictures which I took in spite of myself knowing that it was not going to be of any real photographic merit and even the light was quite bland and uninteresting. Part of my reason for taking the photograph was that it was one of my first forays with a digital camera and I wanted to see how much detail it would resolve.

Enhance

The captured image was as expected, not very exciting, although the building was nicely lit and the detail excellent. I might have left it at that had it not been for the fact that the overcast sky had recorded as nearly pure white. It occurred to me that it might be possible to make an accurate selection and then use the building as part of a composite. I made a duplicate layer and, using Curves, increased the contrast considerably and reduced the image's density to make the difference between stone and sky as great as possible. Using the magic wand tool I selected the sky area enlarging the image to 200% when I got to the very fine detail around the roof and towers. When I was happy with the selection I inverted it and deleted the duplicate layer leaving the selection in place on the original capture underneath. At this point I had chosen three possible skies which I'd opened onto the desktop and sized to match that of the church image. I then copied and pasted the church image on each in turn to see which would work best. This one seemed ideal, partly because the tonal and colour quality appeared compatible, but also because the clouds seemed to have a rather religious ambience. After flattening the image I used the rubber stamp tool to tidy up a few small untidy spots where the selection had not been accurate enough.

"The overcast sky had recorded as nearly pure white and it occurred to me that it might be possible to make an accurate selection and then use the building as part of a composite"

French Road

Capture

There were a number of things about this scene which appealed to me. Firstly I liked the fact that there were no unattractively obtrusive road markings. Things like cat's eyes, double white lines and intrusive road signs can make an otherwise potentially pleasing shot so unattractive and although, theoretically, it's possible to remove such details at the image-editing stage, it's not that easy. Also the shot needs to be particularly stunning to begin with to justify the time and effort. But I also liked the lighting and the colour difference in the trees which has created a transition from dark to light and then dark and light again. The other factor was the fact that it was a very quiet road and I could take my time over framing the shot from the middle of the road. This I did using a long focus lens in order to compress the effect of perspective.

Spooky Trees

Capture

In normal circumstances I prefer to shoot woodland scenes on overcast days or when the light is very soft and diffused. Bright sunlight which creates dense hard edged shadows can very easily create too much contrast with both very bright highlights and large dark areas with little or no detail. The picture here is a good example of this but the scene had an atmospheric quality which appealed to me. There was something about the tangle of silhouetted branches and the harsh lighting which seemed to impart a rather sinister or spooky feeling. I chose the viewpoint which seemed best to create a sense of order from the mass of branches and angled the camera upwards a little to show some sky and foliage. I exposed to obtain good graduation in the highlights and mid tones and allowed the darker areas to become pure black. I used a polarising filter to increase the colour saturation of the blue sky and foliage.

Enhance

On viewing the image, although quite pleased with it, I felt that the colour detracted a bit from the mood of the scene. The blue sky and golden foliage seemed at odds with my memory of the dark, mysterious wood and the way I'd visualised it at the time of shooting. I decided to explore the possibilities of rendering it as a monochrome. Using the channel mixer I increased the red sensitivity and decreased the blue and green which made the blue sky quite a dark tone and made the autumnal foliage brighter and more prominent. It already seemed more atmospheric than the colour image but I thought that I might take it a stage further by adding a tint which gave it a rather dated, period look. To do this I selected two colours from the picker; a dark chocolatey brown and a slightly pinkish sepia and, using the Gradient Map facility, rendered the image in this range of colours. I fine tuned the final effect by adjusting the hue and saturation as well as the density and contrast.

Silver Tree

"The effect of the tree was heightened because the background of fir trees was so much darker and the contrast between the two was quite striking"

Capture

I shot this picture in the Auvergne region of France early on a February morning after there had been a very heavy frost. The countryside was white enough for there to have been a light fall of snow. By the time I came across this small tree most of the frost had melted but, for some reason, it had remained on the tree making it look like one of those silver spray-painted Christmas decorations. The effect of the tree was heightened because the background of fir trees was so much darker and the contrast between the two was quite striking. I used a long focus lens and shot the picture from a fairly distant viewpoint. I wanted to limit the extent of the background because to each side were some lighter trees and branches which would have been very distracting and a closer viewpoint would have included these.

Enhance

The captured image needed little afterwork beyond the use of the burning and dodging tools. The former was used to tone down some lighter tones in the background, where some of the tree trunks and branches had caught the light, and the latter to brighten some of the branches of the silver tree and make them stand out in greater relief.

Spanish Meadow

"I'm a great believer in the maxim that special effects applied to a poor image creates a another poor image with a special effect"

Capture

This is one of those shot that didn't quite work, partly because the lighting was too diffused to create enough contrast in the image and partly because the scene lacked colour. I'd framed the shot to include a large area of the foreground of yellow flowers hoping that this would give the image the impact I wanted it to have. But the resulting capture didn't achieve this and increasing the contrast and colour saturation proved to be ineffective.

Enhance

I'm a great believer in the maxim that special effects applied to a poor image creates a another poor image with a special effect. But I felt that this shot had some merit and I wanted to see if I could produce a result which pleased me. There are numerous filters available which emulate painting effects and I'm sure that most people experiment with them when they first start working on the computer.

I've never found them very satisfying or convincing but I have stumbled across some by-product effects which can, with the right subject, create a pleasing image.

For this image I first found a shot of colourful flowers in a meadow taken on a previous occasion and copied a section of it. I then pasted this into a layer above the shot of the yellow meadow setting the blend mode to multiply. I made a duplicate of this and reversed it, again with the blend mode set to multiply. I used Edit>Transform to adjust the size and position of these two layers and then made a mask for both. Using a soft edged brush at a low opacity I painted out unwanted details from each of the two added layers until I was happy with the way they blended into the yellow meadow. The final step, after flattening the image, was to make a duplicate layer of the composite to which I applied the find edges filter setting the blend mode to multiply. This created the effect you see here.

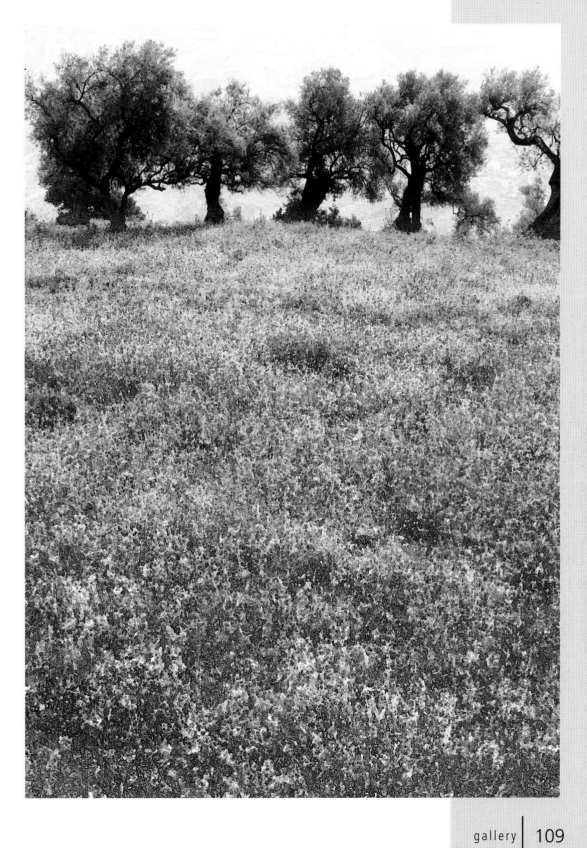

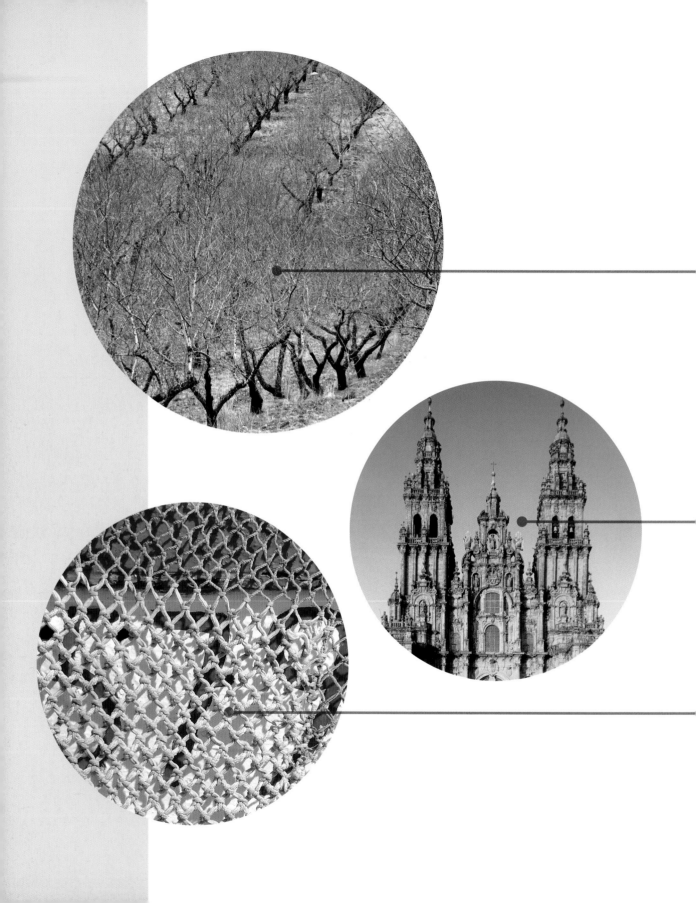

cameras and equipment

sensors and pixels

It's easy to become a bit confused about sensors and pixels as well as some of the other new digital terms when you're new to digital photography because the terminology is so unfamiliar.

In a digital camera the image is captured on a sensor which records it electronically as a series of minute dots of light. Not very different in fact to the way film records an image on the individual grains of silver halide in the emulsion. This is the easiest way to understand it, because an image which consists of a greater number of pixels means they are proportionately smaller pixels producing a higher quality image with the potential to be enlarged to a greater degree, just like a very fine grain film.

One of the most important things which defines the potential image quality of a digital camera is the number of pixels the sensor can record. To make a good quality print from a digital file requires the image to contain 300 pixels per inch. This means that to make a 10 × 8 inch print you need to have 2,400 × 3,000 pixels, which is a total of 7,200,000—or as the jargon has it, just over 7 megapixels. There are other factors in determining image quality, for example, the size of the sensor and the camera's

optics. A camera which has balanced these elements well will create a better quality image than one with a greater number of pixels which is lacking in other aspects.

File sizes can be increased artificially by a process called interpolation. In Image>Image Size if you check the resample box and enter the size you want the image to be the computer will manufacture the extra pixels needed. The success of this process depends on a number of factors, such as the degree by which you wish to increase the image size, the inherent quality of the captured

image, how it was stored and the nature of the subject. I have successfully interpolated an image from 18 to 50 megabytes with no visible loss of quality on some occasions but sometimes, with a different subject, the shortcomings of this technique have become only too apparent.

After downloading bear in mind that small files will open more quickly and can also save editing time. Applying a filter, for instance, to a big file can be very time consuming. Another factor to consider when choosing file sizes is when you are working with layers because a 50 megabyte file can quickly escalate to several hundred megabytes when several layers are involved. On the other hand, a big file can be reduced in size very easily and without loss of image quality whereas increasing the size of an image is likely to involve some degradation of the image.

"To make a good quality print from a digital file requires the image to contain 300 pixels per inch"

These two images are sections from a 17 x 12 inch photograph in which the first is from a 47.5 megabyte file and the second has been interpolated to the same size from a 3 megabyte file.

digital cameras

The digital compact camera is often most people's first step into digital photography and they do offer good value, although compared to the cost of a film cameras they are far less well specified price for price.

Most of these cameras will have an optical viewfinder similar to a film camera and also the ability to view the subject on a screen at the back. It's important to appreciate that the image seen though the optical viewfinder is not identical to that being captured, something which can be a problem when shooting close ups, but which can be overcome by viewing the subject of the rear screen. Many digital camera users prefer to use this method of composing and shooting their pictures but it is much more likely to produce camera shake than holding the camera firmly to the eye.

This image was shot on a 6 megapixel compact camera with a zoom lens smaller than a pack of playing cards and produced a good quality print in excess of 12 x 10 inches. Well lit subjects with a lack of very fine detail and bold blocks of tone or colour tend to be most successful with a camera of this type.

Most of these entry-level cameras will be fitted with a fixed lens, usually with a modest zoom range of 3 or 4 to 1, similar to the film camera equivalent of 35mm to 105mm or 140 mm. They will often also have both an optical and a digital zoom and these are sometimes added together in the camera's specifications.

The optical zoom is achieved by altering the focal length of the lens. However, the digital zoom is the result of enlarging the image by interpolation and is little different to cropping and enlarging the captured image at the editing stage. Depending upon the number of pixels offered, cameras of this

type are capable of producing a good quality print from about 6 × 4 inches up to A3 or even more. Another feature to be considered when choosing a camera is the provision of shooting modes. Auto or program means that the camera sets the combination of shutter speed and aperture according to the lighting conditions. This allows little creative control. If you do wish to have creative control you need a camera which offers either manual settings or aperture/shutter speed priority.

A further consideration is that of the sensor speed options, which are indicated in terms of ISO film speeds and can be from ISO 60 to 1600 or higher. Each doubling of the speed, from ISO 160 to ISO 320 for instance, is equal to using a one stop wider aperture or a one stop slower shutter speed and provides more options when shooting in low light levels. There is a cost, however, when using higher speed settings as it increases the noise level, which is the background interference recorded by the sensor and which has a similar appearance to that of film grain.

The method of storing the captured image is another factor to be taken into account. This can be either CF or Compact Flash cards, SD or Secure Digital Cards, Smart Media Cards, or XD Picture Cards and will depend upon the camera's design and specification.

The choice of most professional photographers is one of the SLR digital cameras because these offer a significantly higher build quality and interchangeable lenses as well as the facility of viewing the image through the camera lens, thereby showing you exactly what is being recorded. The SLR digital camera will offer a wider range of sensor speeds and shooting modes as well as more accurate exposure control and faster focusing. There will typically be a choice of storage formats usually

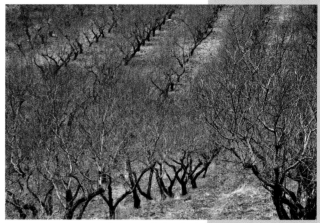

A 17 megapixel professional SLR was used for this shot which needed high resolution and the ability to capture very fine detail.

"The choice of most professional photographers is the SLR digital camera and these offer a significantly higher build quality and interchangeable lenses"

providing the facility to record in RAW mode as well as TIFF or JPEG.

The big advantage of the SLR is the ability to change lenses. Although the fixed zoom on simpler cameras provides the most frequently used focal lengths they do not allow the use of ultra wide angle, very long focus lenses or specialist optics such as shift and macro lenses. Although Digital SLRs are very similar in size and appearance to 35mm film SLRs many of them have sensors which do not fill the 35mm frame and consequently the angle of view produced by a given lens is not the same. In most cases the focal length of a given lens is increased by about 1.4 so a 20 mm wide angle becomes only a 28 mm.

lenses and accessories

The majority of digital cameras have a mid-range zoom as a standard lens whether the camera is a simple compact or an interchangeable lens SLR. While this facility will cover the needs of a large proportion of the photographs you are likely to take, the serious or more specialised photographer using an interchangeable lens camera may well find it desirable to invest in one or more additional lenses.

Landscape photographers for example will find an ultra wide angle lens invaluable on occasions. So too will those who shoot architectural subjects and reportage while wildlife and sports photography will often require the use of a long-focus lens.
Using very wide-angle and long focus lenses also allows a photographer to have more control over the perspective of his or her images. A wide angle lens for instance enables you to include close foreground details as well as distant objects. This exaggerates the impression of perspective making distances appear greater and giving an image a greater sense of depth. A very long focus lens not only enables you to take

close up photographs of distant subjects but can also be used to compress the perspective of an image and produces pictures with a more two dimensional, graphic quality.

While many mid-range zoom lenses will have a close focusing facility a macro lens is the ideal optic

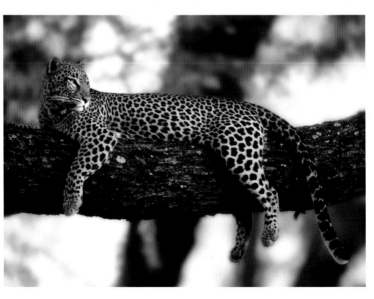

For this shot of a leopard, a 600mm long focus lens was used, an essential piece of equipment for specialists in subjects such as sport and wild life.

A wide-angle shift lens was used to photograph the cathedral of Santiago de Compostella in Spain. It's one of many specialist lenses available to those with digital SLR cameras

❝The ability to edit an image extensively after capture means that the filters which were an essential accessory for those using colour film are largely redundant❞

for close up photography as they allow very small subjects to be photographed at life size. For this type of work bellows units or extension tubes are also essential accessories.

Filters

I now find that I can dispense with most of the large collection of filters I used to carry in my bag along with my rolls of film, but with one important exception, the polarising filter. This filter has the effect of eliminating or reducing the light being reflected from non metallic surfaces, which includes the water droplets which create blue sky and foliage. This has the effect of increasing the colour saturation of a scene and the result is very different to the overall increase in colour saturation which can be made when image editing.

Flash

Many cameras are equipped with an integral flash unit and while this is useful for shooting casual snap shots in poor light it has considerable limitations for more serious photography. This is partly due to the relatively low power which most of them provide but also the fact that it is fixed in position close to the lens. A separate flash gun allows the light to be directed from a position away from the camera and for it to be diffused or reflected, creating much more effective lighting and better image quality. The best results from on camera flash will be obtained when it is used to supplement the ambient light or when the subject is quite close to the background. This will avoid shots of people who look as though they are suspended in a black void.

Using on camera flash can be an effective way of reducing contrast when shooting pictures in harsh sunlight when there are both bright highlights and dense shadows. Using the flash in fill-in mode will allow the correct exposure for the highlights while the flash illuminates the shadows.

making prints

For the majority of amateur photographers the main
purpose of taking a photograph is to have a print
of it. Making your own prints has never been easier
and the cost of a printer that is capable of producing
a high quality result is constantly reducing.

Whatever type and size of printer you decide to buy
your main concern is that the finished print matches
the image on your monitor as closely as possible
in terms of colour balance, density and contrast.
A perfect match can never be possible because the
image on the screen is formed by transmitted red,
green and blue light while the image on the print is
viewed by light reflected by cyan, magenta, yellow
and black inks. Having said this, for most needs a
very adequate match can usually be achieved fairly
easily and even an inexpensive printer these days
will produce a surprisingly good match straight
from the box.

The process of adjusting the print settings so the
output matches the image on the monitor is known
as profiling and it can be done professionally. It
involves making a test print using your chosen

brand and type of paper from a control image
supplied by the profiler who then provides the
settings necessary to obtain a match. Many of the
ink and paper suppliers also offer this service.

If you intend to calibrate your printer yourself, it's
important that your monitor is correctly adjusted
according to the manufacturer's instructions before
you begin and that you view the print under the
correct lighting conditions. Daylight, or a daylight
matching fluorescent tube, is suitable but a print
viewed by normal domestic lighting will seem
redder than it really is. It's also important that when
adjusting the image on the monitor it is screened
from room or window lighting, I prefer to work in
a darkened room. If you use more than one type
of paper, or buy a new set of inks, you may find it
necessary to make further adjustments to the print

settings but my experience has been that there is much less variation in the materials recently.

Even when your printer settings have been correctly adjusted, I think it's still best to make a small test print. The darkroom method is to make a test strip with several different exposures on one piece of paper and this is easy to do on the computer. Using the marquee selection tool you can draw a sequence of strips across a representative part of the image and alter the density of each by about 20% or so making a note of the different settings. You can also apply this method to the colour balance and the contrast if you wish.

Your image should be sized at 300 pixels per inch although you may find there's little noticeable difference in 250 or even less when using textured papers, such as linen or canvas.

A control image made by using the marquee selection tool to add panels of black, 50% grey and white to an image with a good range of colours.

> **"Even when your printer settings have been correctly adjusted, I think it's still best to make a small test print"**

A test strip made by using the marquee selection tool to select five sections of the image in turn and increasing and decreasing the brightness by a factor of 10 each time.

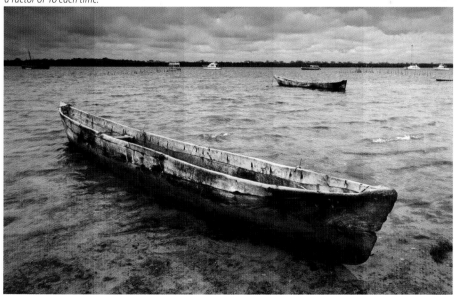

"It's usually necessary to sharpen the image before printing and the best way to do this is to use Unsharp Mask"

Original image

It's usually necessary to sharpen the image before printing and the best way to do this is to use Unsharp Mask found in Filter>Sharpen. There are three sliders; one controls the amount of sharpening, another the radius and the third the threshold. It's important to view the effect of sharpening with the monitor image at either 25%, 50% or 100% because in between settings give a misleading indication of the effect. Each image will require a different setting depending upon the image size, the file size and the nature of the subject. Because of this it's best not to apply unsharp masking until you are ready to print. As a rough guide with an A4 print at 300 pixels per inch and a file size of about 25 megabytes I find something in the region of 200% with radius set to .5 and threshold set to 5 is effective with most subjects. Over sharpening will tend to create pixelation especially in areas where the image has been extensive manipulated.

Final image as sharpened using the Unsharp Mask feature. Amount set to 200%, radius to .5 pixels and threshold set to 5 levels.

Ink Jet Printers

The ink jet or bubble jet printer is the most widely used method of making photo quality prints from digital files and is capable of superb results. Ink jet printers vary hugely in price depending upon the paper size they will handle, from A4 to A0, and the inks they use. There are four basic ink colours, Cyan, Magenta, Yellow and Black but many machines use more with both normal magenta and cyan and also light versions of the same colours, for example.

With some printers it's necessary to replace an entire single four colour cartridge when one of the inks runs out but others allow you to replace a single colour cartridge. It's also possible to buy ink sets that are dedicated for use with monochrome images because the colour inks can result in impure greys.

Printers either use dye based inks or pigment inks. The former tend to produce slightly more vivid colours while the latter have better archival qualities with prints remaining free from fading for up to 100 years or more. Ink jet printers are able to print on a wide variety of papers ranging from glossy photo paper to heavy weight, textured cotton rag and the paper manufacturers now offer an almost bewildering amount of choice.

web images

Our everyday lives are now so bound up with computer technology that it's hard to see how we could now survive without it and photography is just one area where working practices have been transformed by it. The ability to send images by email and to have them displayed on a web site is now available to, at a relatively modest cost and the concept of publishing is no longer limited to the printed page.

Images intended for email and web site display do need to be prepared in a way which makes them as fast to send and download as possible. For these purposes it's not necessary to make the image any larger than about 800 pixels wide or deep and in many cases half this size is enough. They should be saved as compressed JPEG files with a degree of compression which makes the file size as small as possible without compromising quality too much. It's invariably necessary to apply a degree of unsharp masking once the image has been adjusted for size in order to present a crisp clear image on the screen.

There are numerous web sites, which offer keen photographers the facility of having their own portfolio or gallery of images online for all to see and comment on, and very often at no cost. It is rather like belonging to a vast international camera club and as well as having the satisfaction of displaying your own work it can also be very instructional to see the work of others and receive their comments and suggestions.

The web has also made it possible for photographers to generate some income from their photographs. One of the most practical ways for a photographer

This is a page from my own web site showing a
selection of my fine art prints

to earn reproduction fees from his or her images is
with the aid of a photo library, effectively an agency
who takes a percentage of the fee in exchange for
marketing the images.

In the past it was necessary to be 'accepted' by a
photo library and to do this a submission of several
hundred transparencies had to be made. The system
has changed dramatically in recent years. Very few
photo libraries now deal with transparencies and
digital files are supplied directly to clients, often
being down loaded directly from the library's web
site. Because of this there are a considerable number
of libraries who are happy to accept relatively small
numbers of images from individual photographers
without having to go through the process of
submission and acceptance. An added advantage
is that these images will be made available to the
library's clients world wide in a comparatively short
space of time.

**"There are numerous
web sites, which offer
keen photographers the
facility of having their
own portfolio or gallery
of images online"**

saving and storing images

A digital image is in many ways more vulnerable than one recorded on film, as anyone who has suffered a computer crash while working on one will know. It's vital, therefore, to take special care to ensure that your valuable images are stored safely at each stage.

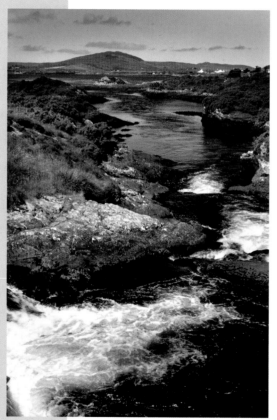

Original image

The computer's hard drive should only be considered as a temporary haven and ultimately it's best to save images to a CD, DVD or separate external hard drive. In the same way, images on the camera's memory card need to be downloaded as soon as practicable.

With memory cards the file format is determined by the camera manufacturer and often with the higher end models there is a choice. RAW files are often preferred by professional photographers because the image is not processed in any way and all of the recorded information remains available after downloading for the photographer to manipulate. RAW files are not compressed which means that a high resolution image will create a large file and take up a lot of memory space. To produce a print, of say 16 × 12 inches at 300 pixels per inch will create a RAW file of about 18 megabytes. This means that if you shoot a lot of pictures in one session you will need to buy high-capacity memory cards or download them onto a laptop computer, a portable hard disk, a CD or a DVD as you go along.

The most commonly used file format for in-camera memory is JPEG. This is a compressed file so some

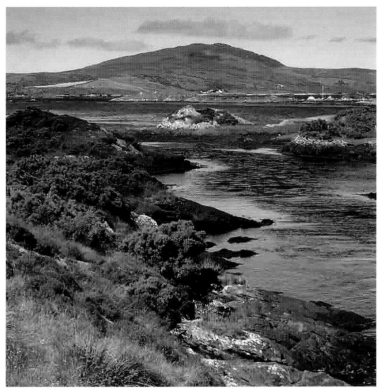

This detail of the image on page 124 shows how maximum JPEG compression will adversely affect image quality.

"RAW files are often preferred by professionals because all of the recorded information remains available after downloading"

of the recorded information is discarded when the image is saved. With most cameras you can choose how much compression is applied and at the minimum compression setting you will not see any lack of quality for most subjects. The advantage of JPEG files is that they are much smaller in relation to the image size they will produce and many more can be stored on a memory card.

It's helpful to have a routine procedure that you follow when saving and storing your images. I've developed the habit of storing the complete memory card as soon as I have access to my computer on CDs or DVDs (in duplicate). Through learning the hard way I've become a bit of a belt and braces person. While the memory card is still in the card reader I like to do a first edit, downloading and making basic levels adjustments of the images

I'm most pleased with. I also store these images on duplicate CDs initially but then add key words and finally transfer them to an external hard disk for long-term storage.

Most image editing programs offer a choice of file formats when saving the image. TIFF files are the most commonly used throughout the image industry; they are compression free and preserve all of the recorded information. This is important if the images are to be used for reproduction or if large, high-quality prints need to be made. But if you intend to make only small en-print sized prints or they are to be used in emails, or on the web, then saving them as a JPEG will save a considerable amount of disk space and you will get many more onto a CD.

organising and filing

With any form of photograph it's very important to have some sort of filing system because an image you can't find readily is one you might just as well not have taken. The method of storage and filing you decide to use depends upon the use to which you will put your pictures and the quantity you wish to use.

Photoshop's keywording facility is found in File>File Info

If you shoot pictures of your family and friends and only make a hundred or so exposures a year then both storage and filing can be done quite efficiently in an album, both as hard copies and also on line. There are numerous opportunities now for storing images on a server free of charge where both you and your friends have access to them.

However, if your output is much greater then this, and you want to be able to find a specific image easily and quickly, then a more sophisticated approach to filing is called for. As a professional photographer it is vital for me to be able to find a requested image as quickly as possible. During the years I shot on film I amassed a considerable number of transparencies which were stored in filing cabinets under various categories and I simply viewed the appropriate storage sheets on a light box and selected the ones I needed. This was not a very hi tech system but it worked.

It's a different matter altogether when you have acquired a significant number of digital images.

At first I could cope by simply storing them on CDs and filing these with a relevant contact reference sheet. I then searched for these visually as I did with the transparencies. But this rapidly became impractical. Most photo libraries now deal only with digital images and they all use a very similar system for storage, filing and searching. The images are stored on a server, effectively a massive hard drive, and filed using key words which are then used to find specific images. Much depends upon the thoroughness of the key wording for a successful system. For most of my images I use the location followed by any other relevant factor, such as the name of any prominent buildings, the season, the sky and so on. If you had just a few pictures of a place then a single keyword identifying it would be sufficient but if you had dozens of something like Notre Dame, for instance, you could add front, back, interior or night etc. to make the search more specific.

Large capacity external hard drives are relatively inexpensive now and are probably as safe and secure as any form of image storage. CDs and DVDs have question marks over their long term stability and the longevity of transparencies is by no means guaranteed these days.

There are a number of programs, such as iView Media Pro and Extensis Portfolio, which are designed to store, keyword and search for images in this way. Most of these programs are quite complex and only necessary for those with very large collections of images. But many of the imaging editing programs offer a simplified facility which is more than adequate for the keen amateur photographer or freelance pro like myself. Photoshop, for example, has a key wording facility found in File>File Info and also in File>Browser and a search facility is available in File>Browser.

"Much depends upon the thoroughness of the key wording for a successful system"

Applications, such as iView Media Pro, allow photographers to create rich portfolios of images that are easily searchable using keywords importable from Photoshop.

glossary

Additive Colour: White light is created when red, green and blue light sources of equal brightness are projected onto the same spot. When the red light is switched off cyan is created by the addition of green and blue, the absence of green produces magenta and without blue the result is yellow.

Algorithm: A mathematical formula which determines a series of steps in a process or operation.

Aperture: A hole of variable size which controls the brightness of an image formed by a lens and used in conjunction with the camera's shutter to control the exposure.

Bit: The basic unit with which information is recorded on a computer.

Brightness Range: The difference in brightness between the darkest tone in a scene or image and the lightest.

Burning: The process of giving additional exposure to a specific area of an image.

Byte: The prime unit of digital information.

Calibration: The process of matching the prime source of an image file to its output.

CD-ROM: Compact Disc-Read Only Memory, a basic method of storing digital information commonly used for both music and images.

CMYK: Stands for cyan, magenta, yellow and black and represents the basic ink colours used in printing processes and known as subtractive colour. Cyan, magenta and yellow are the complementary colours to the primary, or additive colours of red, green and blue and when combined with equal density make black. A black ink is used additionally to ensure maximum density.

Colourise: The process by which colour is added to a monochrome image.

Colour Gamut: The colour range which can be displayed or reproduced by a particular device or process.

Colour Saturation: Describes the purity of a hue. The presence of white or black results in a colour being less saturated while the absence creates a fully saturated hue.

Colour Temperature: A means of measuring the colour quality of a light source expressed as degrees Kelvin. Midday sunlight is 5600 degrees K.

Compact Flash: A storage device widely used in digital cameras.

Compression: A means of reducing the file size of an image or other digital information.

D Max: A measurement of the darkest tone which a process or device is capable of displaying or reproducing.

Depth of Field: The area of acceptably sharp focus behind and in front of the point upon which a lens is focused.

Dodging: The process of reducing the exposure on an image in a specific area to make it lighter.

DPI: The number or ink droplets per inch which a printer is capable of producing.

Duotone: A method of using two inks of different hues to reproduce a monochrome image.

Flat Bed Scanner: A scanner designed to create a digital file from an illustration or document using reflected light.

Focal Length: The distance between the optical centre of a lens and the surface of the camera's sensor, which determines the field of view. A short focal length lens gives a wider angle of view than a longer one.

Gamma: A measure of image contrast.

Histogram: A bar graph which shows the tonal range of an image in terms of the number of pixels which each tone possesses.

Interpolation: A method of enlarging an image by artificially increasing the original number of pixels.

JPEG: A method of storing an image which provides varying degrees of compression to reduce the size of the file.

Megapixel: A unit of one million pixels used to describe the resolution of a digital camera.

Noise: Background interference in a digital image which can degrade it. It is more prevalent in poor light, using higher ISO camera settings and when using long exposures and has an appearance and effect similar to that of film grain.

Pixel: The smallest unit of a digital image.

Pixellation: The result of individual pixels becoming visible in an image which can be caused by over enlargement or when extensive manipulation has been applied.

Polarising Filter: A filter used on a camera lens to eliminate or reduce light which is being reflected from a non metallic surface.

Posterisation: The effect of rendering an image as a small series of visible tonal steps instead of a smooth graduation.

RGB: Stands for red, green and blue, the primary colours which make up white light.

TIFF: The most widely used file format used for the storage of digital images.

Unsharp Masking: The process of making an image appear sharper by increasing edge contrast.